creating radiant
flowers
in colored pencil

GARY GREENE

NORTH LIGHT BOOKS
Cincinnati, Ohio

www.artistsnetwork.com

CALGARY PUBLIC LIBRARY

JUN 2012

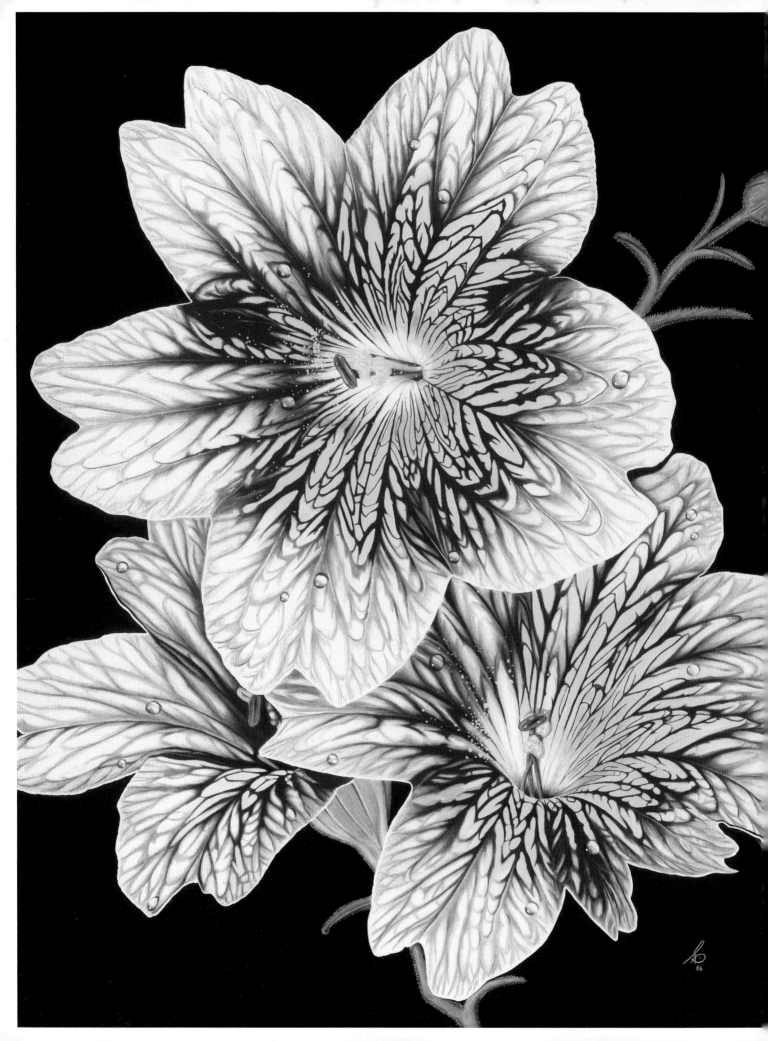

DEDICATION

To my son, Gregg, a constant source of pride and joy

ACKNOWLEDGMENTS

Thanks to my wife, Patti, who spent many hours alone by the television and who took on additional responsibilities while I wrote this book. Special thanks to the six contributing artists, Susan Brooks, Edna Henry, Kristy Kutch, Sherry Loomis, Judy McDonald and Terry Sciko, who contributed their time and considerable talent to this project. Thanks again to Rachel Wolf, Pam Seyring, Joyce Dolan, Amy Jeynes, Angela Wilcox, Pam Koenig and everyone at North Light Books, who are first-rate people to work with.

ARTIST'S STATEMENT

We've all gone shopping for shoes and, after trying on a number of pairs, suddenly know when we have found the right pair. The fit, the look, the statement they make about us—they all come together. In a similar way, this is how colored pencil became my medium of choice as well as the crux of my artistic expression—a melding of personality and purpose.

While receiving my fine art education in mainstream mediums, I endured instructors' relentless admonishments to "work loose," something I was incapable of doing. Fifteen years into my parallel careers of technical illustration, graphics and photography, I was still searching for a medium that fit my fine art aspirations. Then I found myself in an art store where I innocuously picked up a book, *The Colored Pencil* by Bet Borgeson. It was an epiphany.

Colored pencil was love at first stroke! At last I had found a medium that satisfied my obsessions to create paintings with a photographic look. Twenty-eight years ago, creating serious art in colored pencil was indeed different. Most people thought it was something children used to scribble in coloring books, not a fine art medium.

Because colored pencil paintings require a great deal of time to produce (I may spend over 500 hours on a single painting), working from live subjects or *en plein air* is impractical, if not impossible, so I work exclusively from photographs that I compose specifically for art subjects.

If the subjects I paint are man-made, I employ my tools of the trade from my days as a technical illustrator (great fodder for art snobs)—straightedges, templates and curves—to create precise shapes and sharp edges.

After convincing people that my paintings are, indeed, executed entirely with colored pencil, I frequently hear the comment, "Gee, you must have a lot of patience!" to which I facetiously reply, "If you're in front of me in the left lane on the freeway and going the speed limit, you'll soon find out how much patience I have." If my artwork required patience, I could not possibly have done it on an almost daily basis for twenty-eight years and still have retained my amaranthine interest.

Gary Greene

contents

CHAPTER 1

Getting Started • 8

CHAPTER 2

Techniques & References • 18

CHAPTER 3

A Plethora of Flora • 28

— **A** —

— **B** —

— **C** —

— **D** —

— **E** —

— **F** —

— **G** —

— **H** —

— **I** —

— **L** —

— **M** —

— **N** —

— **O** —

— **P** —

WHAT YOU NEED FOR THIS BOOK

SURFACE
Strathmore 3-ply bristol vellum used for most demonstrations in this book. For exceptions, see individual demonstrations.

COLORED PENCILS
See individual demonstrations for colors and brands

TOOLS
Pencil sharpener (electric sharpener recommended)

Erasers: kneaded, imbibed, electric

Erasing shield

Pencil lengtheners

Bestine (rubber cement thinner)

Turpenoid (odorless turpentine)

Containers for solvents and water

Brushes: nos. 2, 4, 6 and 8 round watercolor

Dry applicators for solvent: cotton swabs (recommended); cotton balls, rags, cheesecloth can also be used.

2B and 7H graphite pencils

Desk brush

Fine sandpaper (emery boards)

Drafting or tracing paper

Craft knife with #11 blade

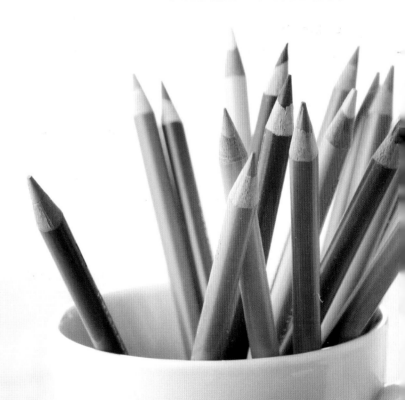

foreward

There is a giddy obsessiveness in Gary Greene's colored pencil renditions. Photo-realistic? No, that would be a rather shoddy compliment. His interpretations have more to do with the interplay of tension and relaxation than with copied flatness.

Gary's work is fascinating. Seeing several of his paintings at a time is mesmerizing. At first glance, our eyes widen, then squint. Foolishly, we try to make sense of the bouncing three-dimensional shapes crashing through what we still believe is a flat drawing surface. But when we let ourselves go, the sensation becomes eerily that of Alice falling into the rabbit hole—exhilarating and scary at the same time.

Compelled to stare, we experience a gradual increase of tactile tingling. Between our fingers we actually feel the delicate thinness of a rose petal; our noses twitch at the heady aroma of garden-fresh bell peppers. And, with a shiver, we scrape our fingernails across the grating texture of ship metal lying at anchor. Gradually, our eyes bob with the abstract waves of blue and purple, gold and red—and we suddenly begin to know Gary. He loves color and form and texture and what they do to the senses, both his and ours. The more we look at his work, the more we're sure he loves to giggle, laugh and tease.

But as quickly as we get a sense of the artist, his work draws us back to the sensual art of looking. Good art always does that. Gary has the ability to make us discover and fall in love with the greatness in the simplest of objects. His interplay of similar, competing and repetitive textures is an attention grabber. But then, just as quickly, the tension relaxes as we actually hear the lapping of wavelets beneath a sailboard or feel the various thicknesses of multicolored paint layers peeling from an old set of oars or smile at the smell of gray metal once covered with slick, glossy car enamel.

Gary's images not only defy the surface, they take us to another world. This new flower book is simply another set of sights and sounds and smells for us to enjoy and learn from.

It's impossible to be neutral about Gary Greene's work—and just as impossible to be neutral about Gary Greene.

Bernard A. Poulin

AUTHOR, *The Complete Colored Pencil Book*

introduction

When my first book, *Creating Textures in Colored Pencil*, was half complete, I approached North Light Books with the idea of writing *Creating Radiant Flowers in Colored Pencil*. My proposal was met with mild enthusiasm until I explained the popularity of flowers as art subjects. Floral paintings constitute approximately one-third of all images I receive from members of the Colored Pencil Society of America (CPSA) for publication in our newsletter. The percentage is the same for entries in the CPSA International Exhibition and the *Best of Colored Pencil* book series (Rockport). With all this interest, why were there no books on painting flowers with colored pencil?

I discovered colored pencil twenty-eight years ago, when there was only one book on the subject: Bet Borgeson's landmark *The Colored Pencil*. Today there are dozens, as many artists are abandoning their watercolors, oils, acrylics and pastels and discovering the creative possibilities of colored pencil. You're now reading the revised edition of the first book on how to paint flowers—always a favorite subject—with colored pencil, the hot "new" art medium!

Creating Radiant Flowers in Colored Pencil depicts a variety of flowers in a simple straightforward way without the visual distractions of backgrounds and containers or the verbal distractions of "artspeak." It's not intended to be a book on botanical illustrations, nor is it a "paint by numbers" book. For example, you may want to paint a still life with a certain kind of flower, such as a zinnia. This book will show you how to paint a zinnia, along with sixty-three other flowers. It's up to you to create the subject, composition, style and mood of your painting. Six talented and highly regarded colored pencil artists who employ styles and approaches different from my own have each graciously contributed three floral illustrations to this book. They are Susan L. Brooks, Edna Henry, Sherry Loomis, Kristy Kutch, Judy McDonald and Terry Sciko. I've duplicated some of the flowers depicted by my colleagues so you may more closely compare our styles.

When I conceived of this book, I thought it would be great fun to do, and it was, even though it was a monumental task requiring over one thousand hours and a year's worth of "art time." My efforts were worthwhile, however, if I can reach artists doing their favorite subject and turn them on to the exciting medium of colored pencil.

Gary Greene
WOODINVILLE, WASHINGTON

GETTING *started*

Compared to other mediums, colored pencil art is inexpensive to create. Consider the cost of high-quality oil, acrylic or watercolor paints, thousand-color sets of pastels (wouldn't it be exciting if colored pencils had that range of colors!), expensive brushes, canvases, easels and so on. It's easy to see that the basics needed to create colored pencil art—pencils, paper surface, sharpener, eraser and desk brush—are a bargain. Some tools and related materials discussed here are necessary; some will make your painting easier but are not essential; and others may be a luxury, suited for the professional. Decide what you need according to your own comfort level and budget.

colored pencils

There are three types of colored pencils: wax-based, oil-based and water-soluble. The pigment in wax-based pencils is bound with wax; in oil-based pencils it's bound with vegetable oil. Wax- and oil-based pencils are similar in almost every respect except that oil-based pencils do not exhibit "wax bloom," a filmy residue or glaze which may appear over heavily applied layers of pigment. Wax bloom is caused by wax rising to the surface.

Water-soluble pencils are usually drier and harder than wax or oil pencils. They don't lend themselves as well to heavy applications of pigment used in techniques such as burnishing. All three types of colored pencil can be used together.

WAX PENCILS

Wax-based is the most common colored pencil. Primary brands are Prismacolor Premier; Derwent Coloursoft, Studio and Artists pencils; and Caran d'Ache Luminance 6901.

Prismacolor pencils are, by far, the most popular colored pencils, primarily because they're most readily available. They have a range of 150 colors and excellent application characteristics, having the softest leads of all brands. Three sets of gray—Cool Grey, Warm Grey and French Grey, intelligently graduated at 10%, 20%, 30%, 50%, 70% and 90%—are unrivaled. Most Prismacolor pencils have good lightfastness.

Derwent makes three lines of wax-based colored pencils: Coloursoft, Studio and Artists series. Coloursoft pencils have thick cores and are nearly as soft as Prismacolors, with a slightly chalky feel. Studio pencils have thicker, softer leads than the Artists series. Studio pencils have round casings, as opposed to the hexagonal Artists series casings. The pencil cores in both the Studio and Artists series are hard, compared to other wax or oil colored pencils, which makes them difficult to use for burnishing. They are good for layering because their points wear down less quickly. Derwent Studio pencils have a range of 72 colors, and the Artists pencils are available in 120 colors. Derwent pencils have good lightfastness.

Caran d'Ache Luminance 6901 wax-based pencils, available in 76 colors, are made with the most lightfast pigments of any colored pencil. Like Prismacolors, they are very soft to apply, but unlike Prismacolors, they do not break or crumble. The Luminance 6901 pencil is the premium colored pencil, but at a premium price.

Verithin pencils, manufactured by Prismacolor, are useful for creating layouts and cleaning up rough edges left when using soft pencils on a toothy surface. Verithins have thin, hard cores coordinated to 36 of Prismacolor's 132 colors.

Art Stix, also made by Prismacolor, are colored pencils in stick form. Use them to cover large areas and to create loose, bold strokes. Art Stix are available in 48 colors coordinated to the Prismacolor line.

OIL PENCILS

Oil-based colored pencils work like their wax counterparts and mix easily with them. Oil-based pencils are available in three major brands: Faber-Castell Polychromos, Caran d'Ache Pablo and Lyra Rembrandt Polycolor pencils.

Made in Switzerland, Caran d'Ache Pablo pencils are available in 120 colors. They are somewhat difficult to find and are more expensive than other brands, but Pablos are worth the extra price. The colors are rich, and the leads are soft and of the highest quality.

Faber-Castell Polychromos are high-quality, oil-based pencils from Germany. The 120 colors are somewhat harder than wax-based pencils, but they don't have a dry or chalky feel. Their thick cores have a special coating that inhibits breakage, enabling Polychromos pencils to keep sharp points and, unlike wax-based colored pencils, leave far fewer crumbs in the work area.

Polycolor pencils, manufactured in Germany, have a 72-color range. They're soft, although some colors are harder than wax pencils but not hard enough to make them less desirable for heavy applications. Polycolor pencils are of superior quality, exhibiting very little breakage and having lightfast colors.

WATER-SOLUBLE (WATERCOLOR)

An emulsifier is included with the binder of water-soluble colored pencils, giving them the ability to be dissolved with water. The five most popular brands of water-soluble colored pencils are Faber-Castell Albrecht Dürer, Caran d'Ache Supracolor II, Derwent Watercolour, Lyra Rembrandt Aquarell and Prismacolor Watercolor.

Faber-Castell Albrecht-Dürer pencils have a range of 120 colors that match their sister oil-based Polychromos pencils. Albrecht-Dürer pencils completely dissolve when water is added. Their hexagonal-shaped casings are slightly thicker than most standard electric pencil-sharpener and pencil-lengthener apertures, making it necessary to whittle the casings—but they're worth the extra effort.

Caran d'Ache Supracolor II has the same 120-color range as the Pablo pencils, and the only way to visually differentiate the two pencils is by Supracolor II's white-tipped caps. Supracolor II pencils have the softest cores of any water-soluble colored pencils and also dissolve completely when water is added.

Derwent Watercolour pencils are available in 72 colors. They're somewhat hard and dry, and may not completely dissolve when water is added.

Lyra Rembrandt Aquarell pencils are water-soluble versions of the oil-based Polycolor line. They have soft application characteristics and dissolve nicely.

Prismacolor Watercolor pencils are available in 36 colors that match popular Prismacolor wax-based colors. Unlike the wax-based color, Prismacolor Watercolors have a dry, chalky feel.

COLORLESS BLENDER PENCILS

Colorless blender pencils mix colors together without adding color. Their cores consist of a wax- or oil-based binder without pigment.

COLORED PENCIL COMPARISON TABLE

pencil type	brand	color range
Soft Wax	Prismacolor Premier	150
Soft Wax	Caran d'Ache Luminance 6901	76
Soft Wax	Derwent Coloursoft	72
Hard Wax	Derwent Artists	120
Hard Wax	Derwent Studio	72
Hard Wax	Prismacolor Verithin	36
Wax Stick	Prismacolor Art Stix	48
Oil-Based	Faber-Castell Polychromos	120
Oil-Based	Caran d'Ache Pablo	120
Oil-Based	Lyra Rembrandt Polycolor	72
Water-Soluble	Faber-Castell Albrecht Dürer	120
Water-Soluble	Caran d'Ache Supracolor II	120
Water-Soluble	Derwent Watercolour	72
Water-Soluble	Lyra Rembrandt Aquarell	72
Water-Soluble	Prismacolor Watercolor	36

surfaces

Colored pencil can be painted on a variety of surfaces including wood, cloth canvas, gesso, drafting film, scratch board and even paper. This array of surface choices enables colored pencil artists to be creative and innovative.

PLATE VERSUS TOOTHY

Smooth surfaces, cold-press boards and papers with a plate finish are good for techniques like simple layering or underpainting. They're not suited for techniques requiring heavy applications of pigment, such as burnishing, because the pigment doesn't have anything to grab onto. Burnishing colored pencil on smooth surfaces will result in pigment merely moving around on the surface. (For explanations of layering, underpainting and burnishing, see chapter two.)

A paper surface that has texture or tooth, such as hot-press board and vellum-finish papers, enables the colored-pencil pigment to anchor in the surface's valleys. A textured paper will allow more layers of pigment on its surface, provide more versatility in color rendition and allow you to paint more detail. When underpainting and layering on a toothy surface, you can create more textures because the valleys don't fill up with pigment. The downside to using a toothy surface is that finishing a painting often takes longer.

WHAT PAPER SHOULD I USE?

Think about how the paper surface will suit the artwork you plan to paint. Also determine if it lends itself to the technique you want to use. You should also like the paper you use. Is it comfortable? Does it feel right? These subjective evaluations are important when choosing a paper surface.

The following are basic points to consider when choosing a paper surface.

- Use acid-free paper; it's always high quality and doesn't deteriorate over time.

- Make sure the surface can withstand erasure and repeated applications of colored pencil, solvent and water.

- A paper's color can determine the style of your painting. Remember that colored pencil is a translucent medium, allowing underlying colors to show through.

SOME PAPER RECOMMENDATIONS

Strathmore or Rising 4-ply museum board are excellent paper surfaces that meet all of the previously described criteria. They're available in white, black and other similar colors in 32" x 40" (81cm x 102cm) sheets and in white in 40" x 60" (102cm x 152cm) sheets.

Strathmore 3- or 4-ply bristol vellum is also an excellent choice. All of the author's illustrations in this book were painted on Strathmore 3-ply bristol vellum. It holds up well under use.

Experiment with different paper textures and colors to find one that best suits you.

OTHER PAPER SURFACES USED BY THE CONTRIBUTING ARTISTS IN THIS BOOK

Susan Brooks	Strathmore 2-ply museum board
Edna Henry	Rising museum board
Kristy Kutch	Rising 2-ply museum board
Sherry Loomis	Strathmore 500 series bristol 4-ply, plate finish
Judy McDonald	Rising Stonehenge
Terry Sciko	Various tinted papers

tools

SHARPENERS

There are four kinds of sharpeners: small manual, handheld models; wall or desk models that are manually operated by a crank; portable battery-operated sharpeners; and plug-in AC models.

Manual sharpeners are not recommended because not only are they time-consuming, but also, more importantly, the frequent, repetitive motion of manual sharpening can cause carpal tunnel syndrome.

Battery-operated electric sharpeners are convenient and portable, but they use many batteries and wear out quickly.

A plug-in sharpener should be capable of sharpening a pencil to a needlelike point.

Whichever sharpener you use, it's "throat" should be shallow, allowing the pencil to be sharpened down to a small stub, which saves money.

ERASERS

A kneaded eraser is commonly used in colored-pencil work. It's good for light erasing or lifting debris lodged in the paper surface's tooth after heavy application. For heavy-duty erasing, try an imbibed eraser, which will quickly remove thick layers of colored pencil without damaging the paper surface.

ELECTRIC ERASER

Electric erasers increase efficiency. They're available in battery, rechargeable and AC plug-in models. A variety of eraser "strips" are available for the larger AC and rechargeable erasers, but white vinyl and abrasive ink erasers (not recommended for colored pencil) are the only erasers available for the small, battery-powered types. Small erasers are less obtrusive and make precise erasures, especially if you sharpen the eraser strips to a point with an emery board, while larger AC and rechargeable models are better for erasing large areas.

BESTINE (RUBBER CEMENT THINNER)

Bestine is used extensively in this book to depict subtle textures and colors. Although Bestine's ingredients are toxic, this solvent is safe if used with a little common sense. Handle Bestine in a well-ventilated room, avoid getting the liquid on your skin, and don't use it while smoking.

When using Bestine, pour a minimal amount into a small, narrow-mouthed glass jar with a screw-on lid. Then dip an applicator into the solvent and immediately cap the jar. This minimizes evaporation and also makes handling this material less hazardous.

If you're hypersensitive to solvents, use water-soluble pencils. The effect will be somewhat different, but you'll still have good results.

TURPENOID (ODORLESS TURPENTINE)

Turpenoid will produce effects similar to washes with water-soluble pencil or Bestine. The differences are that Turpenoid dries more quickly than water, resulting in a more even application of color. Evaporating less quickly than Bestine, Turpenoid produces an uneven effect. Always use adequate ventilation.

CONTAINER FOR SOLVENT

A small glass container with a narrow neck and a tight-fitting screw-on cap is necessary for storing solvents.

PENCIL LENGTHENERS

These pencil holders allow you to grind you pencil down to a stub limited in length only to the depth of your pencil sharpener.

BRUSHES

If you have good brushes, use them for water, but never use them with Bestine unless you're independently wealthy. In time, solvents will dissolve the glue that holds the bristles together.

All brushes mentioned in this book are round watercolor brushes unless otherwise stated.

DRY APPLICATORS

You can apply solvent with a variety of materials. Use cotton swabs, cotton balls, rags and even cheesecloth. Use swabs with long, wooden applicators, available online or at hospital supply stores. Long-handled swabs are better quality and prevent solvent from getting on your fingers.

GRAPHITE PENCIL

Use a 2B pencil for preliminary layouts.

DESK BRUSH

Sometimes called a foxtail brush, a desk brush helps to keep your art free of debris. Many artists use a large paintbrush or other inexpensive devices, and some artists use canned air instead of a brush to avoid any possibility of damaging the art.

SANDPAPER

Use an emery board to sharpen electric eraser strips or dull pencil points.

ERASING SHIELD

An erasing shield is a thin, flat piece of aluminum with assorted openings. It allows you to erase tight areas.

CONTAINER FOR WATER

Keep your water container small. Water-soluble pencils do not require large amounts of liquid.

LIGHT

To reduce the possibility of misrepresenting colors, use full-spectrum lighting with a color temperature rating of 5600 degrees. Because tungsten lighting, such as light bulbs, has an orange cast and fluorescent light has a greenish color, both of those light sources may lead to rendering colors inaccurately.

Improper lighting can result in eyestrain because colored pencil requires close work. Consider using more than one lamp for adequate lighting. Ott-Lite desk lamps and similar products are good lighting choices.

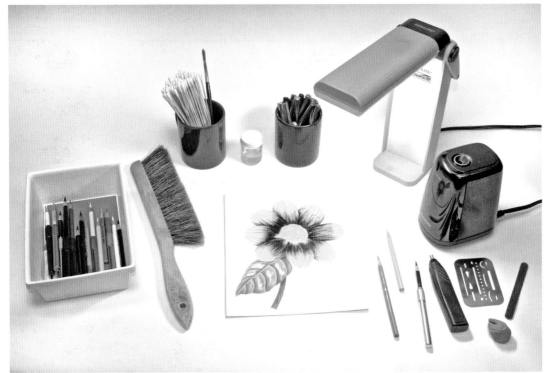

Tools of the Trade

(clockwise from left) Pencils in holding container, desk brush, cotton swabs and brush, container for solvent, pencil legtheners, lamp, AC sharpener, erasing shield, emery board, kneaded eraser, battery-operated electric eraser, pencil in pencil lengthener, colored pencils

master color list

The following charts show the colors used for the illustrations in this book. All colors listed in the color palettes at the beginning of each project are Prismacolor brand unless otherwise noted. The following abbreviations are used:

(Verithin)	Prismacolor Verithin
(Pablo)	Caran d'Ache Pablo
(Derwent WS)	Derwent Watercolour
(Derwent Artists)	Derwent Artists
(Derwent CS)	Derwent Coloursoft
(Supracolor)	Caran d'Ache Supracolor II
(Polychromos)	Faber-Castell Polychromos
(Luminance)	Caran d'Ache Luminance 6901

DERWENT WATERCOLOUR

27 Blue Violet Lake

48 May Green

43 Bottle Green

08 Middle Chrome

54 Burnt Umber

51 Olive Green

50 Cedar Green

17 Pink Madder Lake

06 Deep Cadmium

04 Primrose Yellow

28 Delft Blue

58 Raw Sienna

46 Emerald Green

21 Rose Madder Lake

23 Imperial Purple

18 Rose Pink

41 Jade Green

30 Smalt Blue

38 Kingfisher Blue

32 Spectrum Blue

33 Light Blue

11 Spectrum Orange

26 Light Violet

05 Straw Yellow

22 Magenta

64 Terracotta

FABER-CASTELL POLYCHROMOS

149 Bluish Turquoise

163 Emerald Green

185 Naples Yellow

193 Burnt Carmine

159 Hooker's Green

121 Pale Geranium Lake

111 Cadmium Orange

192 Indian Red

126 Permanent Carmine

107 Cadmium Yellow

117 Light Cadmium Red

167 Permanent Green Olive

278 Chrome Oxide Green

106 Light Chrome Yellow

267 Pine Green

189 Cinnamon

132 Light Flesh

127 Pink Carmine

102 Cream

171 Light Green

129 Pink Madder Lake

115 Dark Cadmium Orange

145 Light Phthalo Blue

191 Pompeian Red

108 Dark Cadmium Yellow

162 Light Phthalo Green

136 Purple Violet

130 Dark Flesh

128 Light Purple Pink

194 Red-Violet

158 Deep Cobalt Green

135 Light Red-Violet

124 Rose Carmine

172 Earth Green

133 Magenta

118 Scarlet Red

168 Earth Green Yellowish

170 May Green

138 Violet

PRISMACOLOR PREMIER

PC 912 Apple Green	PC 1065 Cool Grey 70%	PC 1076 French Grey 90%	PC 995 Mulberry	PC 948 Sepia
PC 905 Aquamarine	PC 1067 Cool Grey 90%	PC 1034 Goldenrod	PC 911 Olive Green	PC 945 Sienna Brown
PC 935 Black	PC 906 Copenhagen Blue	PC 909 Grass Green	PC 918 Orange	PC 936 Slate Grey
PC 996 Black Grape	PC 914 Cream	PC 1026 Greyed Lavender	PC 921 Pale Vermilion	PC 1003 Spanish Orange
PC 1024 Blue Slate	PC 925 Crimson Lake	PC 1031 Henna	PC 1008 Parma Violet	PC 913 Spring Green
PC 928 Blush Pink	PC 924 Crimson Red	PC 993 Hot Pink	PC 1006 Parrot Green	PC 917 Sunburst Yellow
PC 1028 Bronze	PC 1009 Dahlia Purple	PC 1007 Imperial Violet	PC 907 Peacock Green	PC 944 Terra Cotta
PC 943 Burnt Ochre	PC 908 Dark Green	PC 901 Indigo Blue	PC 1025 Periwinkle	PC 903 True Blue
PC 916 Canary Yellow	PC 931 Dark Purple	PC 1012 Jasmine	PC 929 Pink	PC 910 True Green
PC 926 Carmine Red	PC 947 Dark Umber	PC 934 Lavender	PC 1018 Pink Rose	PC 937 Tuscan Red
PC 1020 Celadon Green	PC 1013 Deco Peach	PC 992 Light Aqua	PC 922 Poppy Red	PC 932 Violet
PC 989 Chartreuse	PC 1014 Deco Pink	PC 920 Light Green	PC 944 Process Red	PC 933 Violet Blue
PC 1017 Clay Rose	PC 1011 Deco Yellow	PC 927 Light Peach	PC 1032 Pumpkin Orange	PC 1056 Warm Grey 70%
PC 1023 Cloud Blue	PC 1068 French Grey 10%	PC 941 Light Umber	PC 1030 Raspberry	PC 1058 Warm Grey 90%
PC 1059 Cool Grey 10%	PC 1069 French Grey 20%	PC 956 Lilac	PC 1019 Rosy Beige	PC 938 White
PC 1060 Cool Grey 20%	PC 1070 French Grey 30%	PC 1005 Lime Peel	PC 1001 Salmon Pink	PC 1004 Yellow Chartreuse
PC 1061 Cool Grey 30%	PC 1072 French Grey 50%	PC 930 Magenta	PC 923 Scarlet Lake	PC 942 Yellow Ochre
PC 1063 Cool Grey 50%	PC 1074 French Grey 70%	PC 1033 Mineral Orange	PC 1093 Seashell Pink	PC 1002 Yellowed Orange

PRISMACOLOR VERITHIN

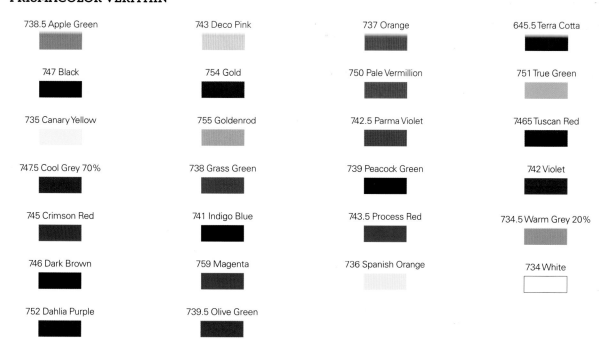

738.5 Apple Green	743 Deco Pink	737 Orange	645.5 Terra Cotta
747 Black	754 Gold	750 Pale Vermillion	751 True Green
735 Canary Yellow	755 Goldenrod	742.5 Parma Violet	7465 Tuscan Red
747.5 Cool Grey 70%	738 Grass Green	739 Peacock Green	742 Violet
745 Crimson Red	741 Indigo Blue	743.5 Process Red	734.5 Warm Grey 20%
746 Dark Brown	759 Magenta	736 Spanish Orange	734 White
752 Dahlia Purple	739.5 Olive Green		

CARAN D'ACHE PABLO DERWENT ARTISTS DERWENT COLOURSOFT

CARAN D'ACHE PABLO	DERWENT ARTISTS		DERWENT COLOURSOFT
025 Green Ochre	6600 Chocolate	4200 Juniper Green	C190 Pink
053 Hazel	0600 Deep Cadmium	0700 Naples Yellow	C170 Soft Pink
019 Olive Black	0300 Gold	0400 Primrose Yellow	
015 Olive Yellow	5010 Green Grey	3400 Sky Blue	
011 Pale Yellow	4100 Jade Green		

CARAN D'ACHE SUPRACOLOR II CARAN D'ACHE LUMINANCE 6901

CARAN D'ACHE SUPRACOLOR II	CARAN D'ACHE LUMINANCE 6901
404 Brownish Beige	041 Apricot

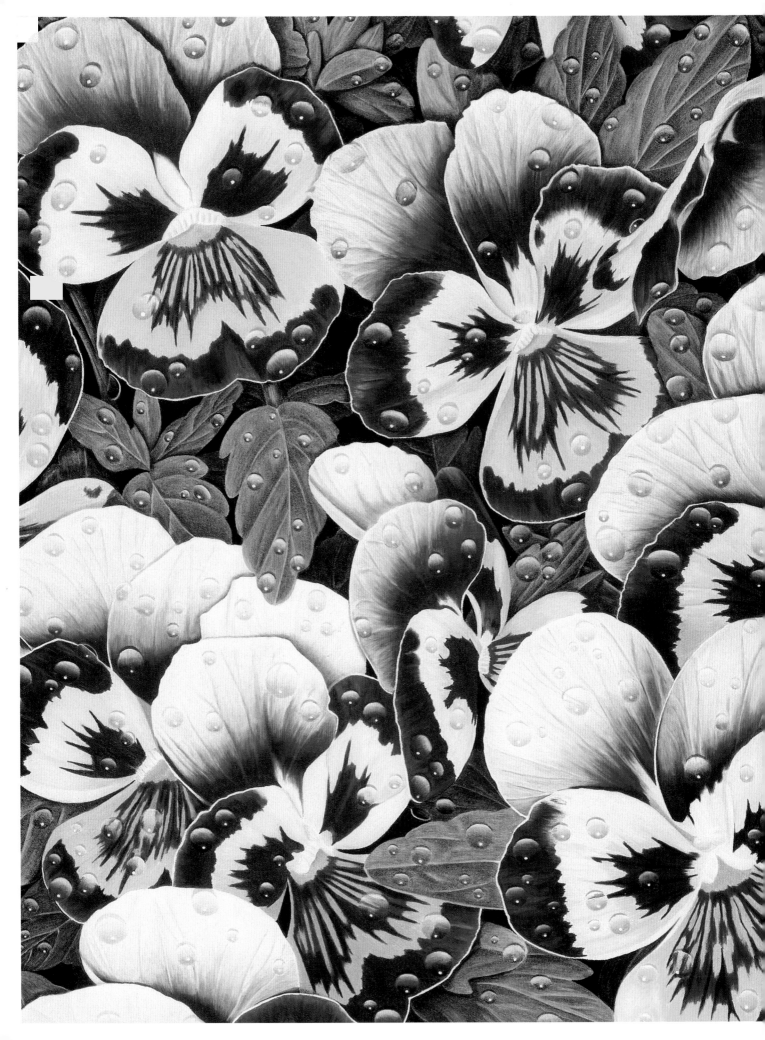

TECHNIQUES
& references

In this chapter we'll explore the techniques used to create paintings of flowers with colored pencil and how to find and use subject material.

Three techniques employed to create our flowers are layering, burnishing and underpainting. These techniques are usually used in combination, depending on the color, texture or level of detail needed in a flower. This chapter shows you basic demonstrations of these three techniques. After learning the basics, don't be afraid to break the rules and try your own variations, or, better yet, invent your own technique.

layering

Layering is a technique employing light applications of color layered on top of each other, allowing the tooth of the paper surface to show through. Paper plays an important role in layering. The appearance, texture and mood of a painting may be manipulated by using surfaces of varying tooth and color. Layering is used in the beginning stages of burnishing or applied on top of an underpainting to depict texture or used in combination with both techniques.

When layering, start with the darkest values, using light pressure and small, circular strokes that follow the contours of the object you're painting. For example, the layering demonstration starts with the lighter color, yellow, to minimize its contamination by the stronger red hue. Adding colors creates complex hues, values and gradations, resulting in wonderfully exciting luminous and elaborate paintings. Sherry Loomis, one of this book's contributing artists, is a master of this technique.

I've demonstrated the layering technique with a drawing of a dahlia petal.

Colored Pencil Facts & Tips

- Colored pencil, once applied, cannot be completely erased without damage to the paper surface.

- When using graphite or hard colored pencils in layouts, always use light pressure, or you may leave an undesirable impressed line on the painting that will be difficult to cover, especially when layering.

- Colored pencil is a translucent medium. It's not transparent like watercolor nor opaque like oil or acrylic; it's somewhere in between. Base colors and values show through layers of color built on top of them.

- Always erase graphite lines used for layouts before applying color, or the graphite will show through, due to the translucent quality of colored pencils. Graphite is nearly impossible to erase after color is applied. Use graphite for your rough layouts. Then draw the finished layout lines next to—not on top of—them with colored pencil, preferably Verithin. Remove the graphite with a kneaded eraser. The colored pencil lines will remain because they can't be completely erased.

- Use a hair dryer to dry water washes to minimize paper buckling.

Download free bonus materials at **Artistsnetwork.com/Creating-Radiant-Flowers-In-Colored-Pencil**

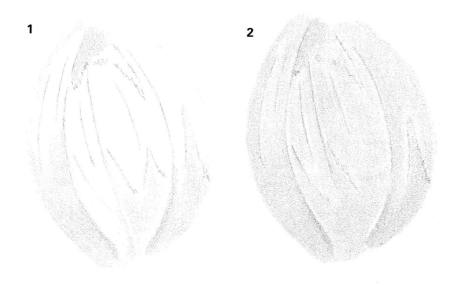

1. Layer Goldenrod and Sunburst Yellow. Notice I used Crimson Red (Verithin) for the layout lines.

2. Layer Canary Yellow.

3. Layer Crimson Red.

4. Layer Pale Geranium Lake (Polychromos).

5. Layer Poppy Red.

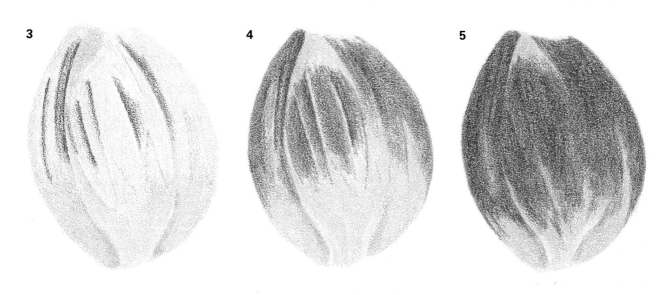

burnishing

Burnishing involves layering at least two colors, blending them together with a light color—often white—or a colorless blender, then layering more colors and blending again. This is repeated until the paper surface is entirely covered. Always complete the lighter areas of color first to prevent darker colors from adjacent areas being dragged into lighter areas.

Apply colors lightly at first by layering lighter colors on top of darker colors. Repeat this process until the paper surface is approximately two-thirds covered with pigment but still showing through. Then use a white, lighter or colorless pencil and, with a heavy pressure, burnish the layered colors together. Now layer the same colors again over the area just burnished. Repeat layering and burnishing until the paper surface is completely covered with colored-pencil pigment.

You can also burnish with solvents, colorless markers or dry applicators. I've demonstrated the burnishing technique on the dahlia petal.

Colored Pencil Facts & Tips

- Unlike liquid mediums, which are mixed separately on a palette, colored pencil hues are created by mixing directly on the art as you paint. It's a good idea to plan colors on a separate piece of paper before starting to paint. Never use just one color. Always combine at least two colors to produce more interesting hues.

- If possible, complete the lightest areas of your painting first. This minimizes dragging undesired darker colors into the light areas.

- Clean up ragged edges with a Verithin colored pencil.

- Sharp pencil points yield intense color but cover a smaller area. The effect is reversed as the point becomes dull.

- Keep art free of debris left by the pencil as you work. If debris gets lodged in the paper's tooth, it can cause contamination of color.

- When using Bestine with a cotton swab, discard the swab after each pass. Do not dip it back into the Bestine.

- If using white paper, create sparkling highlights by leaving those areas free of pigment.

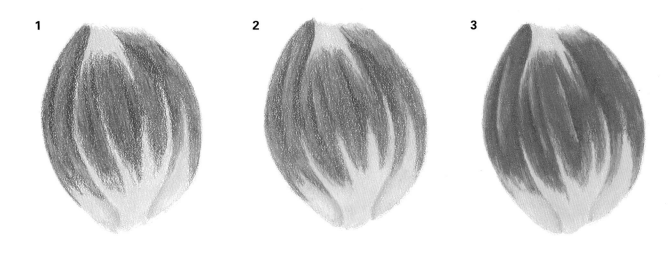

1. Begin after the last step of the layering technique. Use White to burnish all but the darkest values.

2. Burnish the yellow and into the red area with Canary Yellow.

3. Burnish the red area with Crimson Red, Pale Geranium Lake (Polychromos) and Poppy Red. Then burnish the entire petal with Canary Yellow. Repeat this step until the surface is entirely covered.

underpainting

Underpainting (wash) serves a dual purpose: to color white paper without destroying its tooth, allowing it to depict texture; and to quickly cover the paper surface with pigment, decreasing the time spent repeatedly layering and burnishing.

There are two basic methods of underpainting: using water-soluble pencils thinned with a water wash or using wax- or oil-based pencils and washing with solvent. Both methods employ layering at the onset, but instead of burnishing with white to cover the paper's surface, the colored pencil pigment is dissolved with either water or solvent, becoming a ground which will show through subsequent layering.

When underpainting, start with the darkest value of the lightest color.

WATER-SOLUBLE COLORED PENCILS

Colored pencil can be liquefied to resemble watercolor by several different means. Water-soluble (watercolor) pencils are often used to produce washes by layering dry pencil and then washing with a wet watercolor brush. It's advisable to use a small brush and wet small areas at a time to prevent the paper surface from warping. Since water requires a long time to dry, even when accelerated with a hair dryer, washes produce a textured or mottled effect. This is excellent for flowers such as nasturtiums, but flowers that exhibit smooth gradations of color need a fast-drying agent, such as rubber cement thinner, as described in the next paragraph.

WAX- AND OIL-BASED COLORED PENCILS

Wax- and oil-based colored pencils can be dissolved with a variety of solvents, including turpentine, bleach, colorless marker or even lighter fluid (not recommended). Instead of burnishing, solvent is applied to a moderately layered area of colored pencil. A solvent that works for the effects in this book is Bestine (rubber cement thinner). Subtle textures and color gradations can be created with this solvent because it evaporates quickly. It can be applied with a watercolor brush or a cotton swab, each with a different effect.

Once dissolved with Bestine, a layered area of color becomes permanent allowing additional layers and washes of color on top without affecting the previous layer. Think of the possibilities!

COMBINE METHODS

Washes with Bestine can also be painted over water-soluble washes, and vice versa, without affecting the underpainting. Colored pencil can be burnished over areas that have been underpainted with either water or solvents. Even more possibilities!

ADJUST COLOR

Areas underpainted with either water or solvent can be lightened easily with a kneaded eraser or an electric eraser equipped with an imbibed eraser strip. Color can then be layered, washed and burnished. Underpainting will cover paper more quickly but offers less control over color and yields less intense hues. Once again, the dahlia petal is used to demonstrate the underpainting technique.

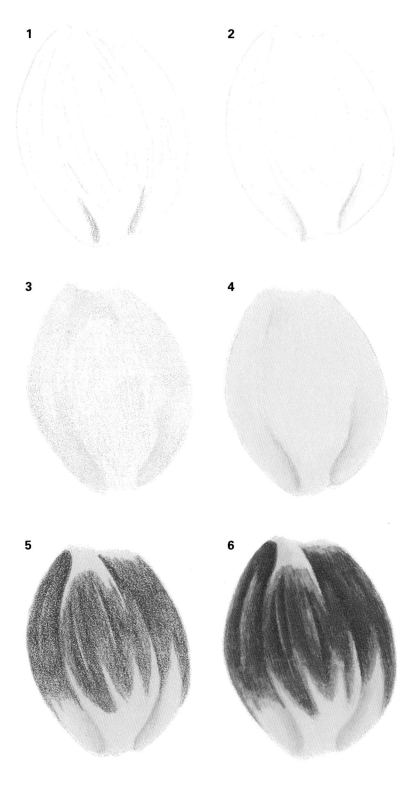

1. Layer Goldenrod.

2. Wash with Bestine and a cotton swab.

3. Layer Sunburst Yellow and Canary Yellow.

4. Wash with Bestine and a cotton swab.

5. Layer Crimson Red, Pale Geranium Lake (Polychromos) and Poppy Red.

6. Wash with Bestine and a medium brush in the red area. The brush provides more control with the strong red color than a cotton swab. Burnish with Crimson Red, Pale Geranium Lake (Polychromos), Poppy Red and Canary Yellow.

reference material

Flowers are everywhere, so obtaining good reference material should be easy. Wrong! To truly capture a flower in colored pencil, or any medium, you need to observe and understand that flower's structure. This enables you to know which details to include and which to omit. No matter what style you use, whether it's realistic, stylized or abstract, you need excellent reference material to produce excellent flower paintings.

Because colored pencil paintings require more time to complete than those in most other mediums, perishable items like flowers, especially cut flowers, may wither and die long before you finish your painting if you're using those flowers as live subjects. The solution to this problem is to work from photographs.

CAMERA EQUIPMENT

Ideally, you should work from your own reference material, which makes having at least a working familiarity with photography important. The better you are at taking photographs, the better your artwork will be. Use a DSLR camera that has interchangeable lenses (not a point-and-shoot camera). If necessary, use a tripod and an electronic flash,.

LENSES

Macro lenses are the ultimate for photographing flowers. Macros are available in two basic focal lengths: 100mm or 50mm. All are fixed focal length lenses, in other words, not zoom lenses, despite some manufacturer's claims that their zoom lenses have macro settings. The 100mm macro is ideal for flowers, but it can be pricey. The less expensive 50mm macro lens may not have the magnification of the 100mm, but it costs considerably less. If macro lenses are not in your budget, close-up (diopter) filters can be attached to your lens. These filters are available in magnifications of +1, +2 and +3.

CAMERA SETUP

The incredible overnight transformation of digital over film photography is due to digital's many advantages: the ability to instantly see what you have photographed and to then make changes, the ability to photograph under any lighting conditions without having to change film or add a filter, the ability to change the light sensitivity (ISO) from shot to shot and the elimination of the expense of buying and processing film. There are trade-offs, though. You should have a computer with sufficient storage to hold your photos, photo editing software to adjust your images and a color ink-jet printer for making reference prints.

When photographing flowers for reference, use the highest resolution on your camera, along with the raw mode, which allows maximum image control; stop down the lens as much as possible with the smallest f-stop (largest number) for maximum depth of field, and use low ISO settings for well-lit subjects and higher ISOs for lower light situations. At this writing, photos shot with ISOs over 800 will begin to show noise, the digital equivalent to film grain, and lose sharpness.

TRIPOD

For the type of flower drawings presented in this book, you should aim for photos with flowers in sharp focus. This requires using the smallest possible f-stop (largest number) when making a photograph. This makes using slower shutter speeds or higher ISOs necessary. Holding your camera in your hand while using lower shutter speeds produces less-than-sharp

DSLR camera with a 100mm macro lens

images, but many DSLR cameras have image stabilization built into select lenses or their bodies to compensate for the photographer's body movement. With image stabilization, tiny motors in the lens or camera body counteract human body movements, but there are limits, beyond which fall the requirements of floral photography. This is why it's necessary to mount your camera on a tripod.

A good tripod should be sturdy, light and portable. Carbon fiber tripods are lighter than their aluminum counterparts, but they're also much more expensive. Other desirable features are levers, as opposed to screw-on attachments, to expand the legs, and a tripod fitted with a ball head with a quick release for ease of operation.

ELECTRONIC FLASH

Instead of a tripod, some photographers prefer using an electronic flash separate from the pop-up flash that's built into many DSLR cameras. Having your own light source can maximize depth of field (what is in focus near and far) without necessitating a tripod. The main drawback with electronic flash is that a scene's natural lighting will probably be compromised. Many cameras offer wireless flash capabilities, enabling you to easily place the flash exactly where it will best illuminate the subject. An even more advanced lighting technique for photographing flowers is using a ring light—a circular flash that attaches to the lens, providing excellent, even lighting.

OTHER REFERENCES

Many artists seem averse to photography, but I think it's the most important tool in producing excellent art. Photography gives you the ability to really see the subject first hand.

If, for whatever reason, you still wish to avoid photography, there are many reference materials available for painting flowers: books and magazines on gardening, seed catalogs and seed packages; however, the sharpness or accuracy of color in these printed images will never equal images you photograph yourself.

You can copy someone else's photographs for practice and hang those paintings in your living room, but remember, if you plan to exhibit or sell a painting that you've based on a photograph from another source, you must change the image enough so it won't be recognizable; otherwise, you may be in violation of copyright laws.

Colored Pencil Paintings and Their Reference Photos

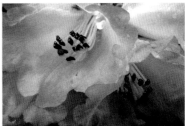

Reference Photo

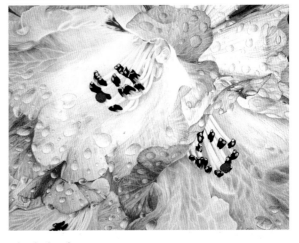

Rhododendrons
32" x 40" (81cm x 102cm)

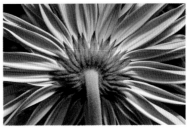

Reference Photo

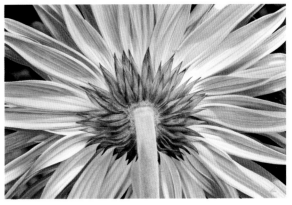

Backpetals
19" x 28" (48cm x 71cm)

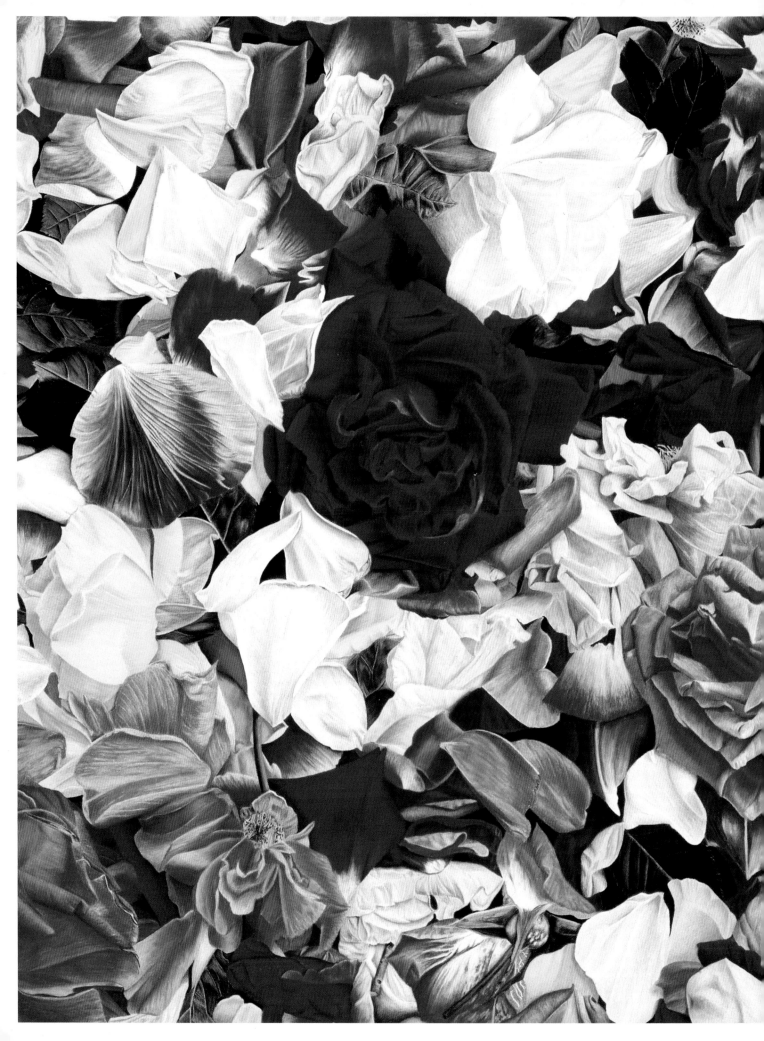

A PLETHORA
of flora

And now—the flowers! The rest of this book is devoted to demonstrations of how to paint different types of flowers with colored pencil.

A variety of flowers are represented. Some are common garden flowers—such as roses, irises, pansies and tulips—that are painted and drawn so often they may seem trite. But, after learning the basics, think about painting these usual flowers in unusual ways. Remember, "A rose is a rose is a rose."

I've also selected flowers I find unusual because of their interesting color, texture, shape or lack of "respect" given to them. Cacti, tropical flowers and wildflowers—they're all here.

In order to make the instructions as clear as possible to most people, I've not used strict botanical terms in defining the parts of the flowers.

Let's begin.

azalea

COLOR PALETTE

Parma Violet (Verithin)

Black Grape

Violet

Parma Violet

Lilac

Lavender

Light Red-Violet
(Polychromos)

White

Violet (Verithin)

Light Umber

Dark Brown (Verithin)

Burnt Ochre

Goldenrod (Verithin)

Cream

Dahlia Purple (Verithin)

Magenta (Verithin)

Cool Grey 10%

Cool Grey 50%

Cool Grey 90%

Deep Cobalt Green
(Polychromos)

Olive Green

Lime Peel

Olive Green (Verithin)

Reference Photo

PETALS

1. Indicate veins with Parma Violet (Verithin). Layer dark values with Black Grape, Violet. Layer Parma Violet, Lilac, Lavender, Light Red-Violet (Polychromos). Leave a line free of color parallel to lavender vein line.

2. Wash with Bestine and a highly saturated no. 6 brush.

3. Lightly burnish with White, dragging color in to highlight vein line.

4. Lightly burnish with Parma Violet, Lilac, Lavender, Light Red-Violet (Polychromos). Repeat steps 3 and 4 as necessary. Sharpen edges with Lavender or Violet (Verithin).

5. Lightly burnish spots at center with Light Umber.

PISTILS

6. Layer darkest values with Dark Brown (Verithin). Layer Burnt Ochre, Goldenrod (Verithin). Lightly burnish with Cream.

7. Layer Dahlia Purple (Verithin), Magenta (Verithin). Lightly burnish dark values with Cool Grey 50%, light values with Cool Grey 10%, White. Burnish with Dahlia Purple (Verithin), Magenta (Verithin).

LEAVES

8. Lightly burnish with Cream. Wash with Bestine and a cotton swab.

9. Randomly layer shadows with Cool Grey 90%. Layer Deep Cobalt Green (Polychromos), Olive Green, Lime Peel, leaving some Cream underpainting showing.

10. Wash with Bestine and a highly saturated no. 6 brush.

11. Lightly burnish with Deep Cobalt Green (Polychromos), Olive Green, Lime Peel. Dab with Bestine and a no. 4 brush. Repeat burnishing as necessary. Sharpen edges with Olive Green (Verithin).

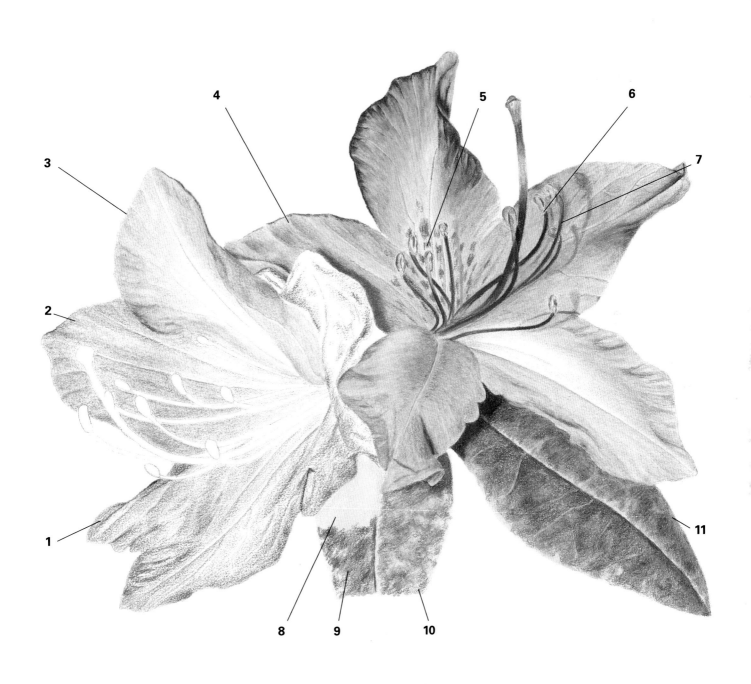

anthurium

COLOR PALETTE

French Grey 10%	Goldenrod	Crimson Red	Olive Black (Pablo)
French Grey 20%	Sunburst Yellow	Scarlet Lake	Grass Green
French Grey 30%	Spanish Orange (Verithin)	Poppy Red	Olive Green
French Grey 50%	Tuscan Red	White	Lime Peel
Warm Grey 20% (Verithin)	Crimson Lake	Cool Grey 90%	Cream

CENTER

1. Layer French Grey 50%, 30%, 20%. Leave "bumps" free of color. Burnish with French Grey 10%. Indicate shadow on one side of bumps with Warm Grey 20% (Verithin).

2. Define pattern by burnishing with Goldenrod. Burnish with Sunburst Yellow. Dab with Bestine and a no. 2 brush. Redefine pattern with Spanish Orange (Verithin).

PETAL

3. Layer darkest values with Tuscan Red. Layer Crimson Lake, Crimson Red, Scarlet Lake, Poppy Red, leaving highlight areas free of color.

4. Burnish with White.

5. (See the finished painting.) Burnish darkest values with Crimson Lake. Burnish with Crimson Red, Scarlet Lake, Poppy Red, leaving highlight areas free of color.

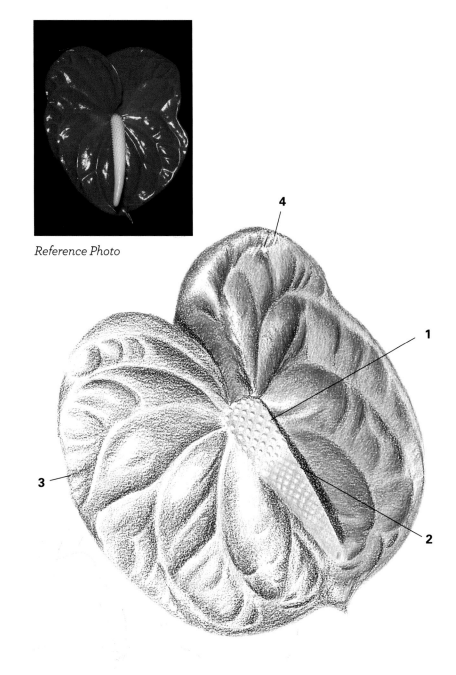

Reference Photo

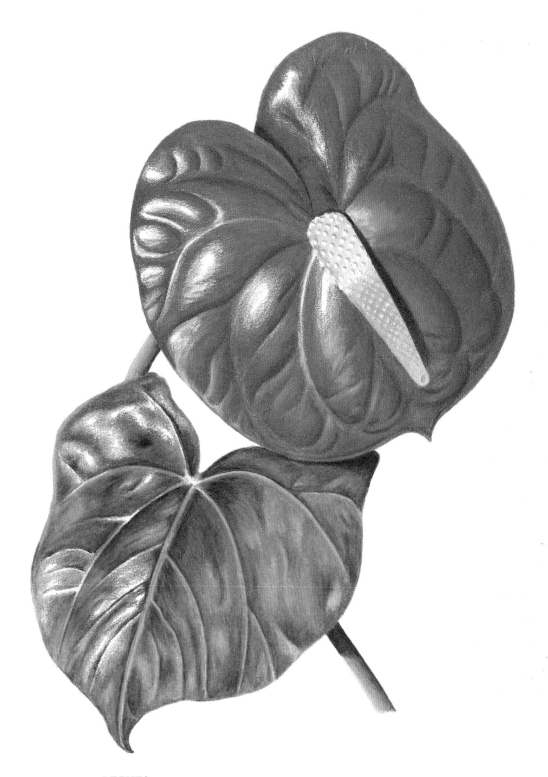

LEAVES

6. Layer darkest values with Cool Grey 90%. Layer Olive Black (Pablo), Grass Green, Olive Green, leaving highlight areas free of color. Burnish with Lime Peel, Cream. Burnish dark values with Olive Black (Pablo), Olive Green. Repeat burnishing with Lime Peel and Cream, as required.

amaryllis

COLOR PALETTE

Cool Grey 10%

Cool Grey 20%

Cool Grey 50%

Blush Pink

Light Purple Pink
(Polychromos)

Process Red

Apple Green

Spring Green

Chartreuse

Yellow Chartreuse

Cream

True Green (Verithin)

Dark Green

Henna

Goldenrod (Verithin)

Spanish Orange (Verithin)

Grass Green

Olive Green

Olive Green (Verithin)

Reference Photo

PETALS

1. Layer darkest values with Cool Grey 20%. Layer Cool Grey 10%. Then wash with Bestine and a no. 6 brush.

2. Layer Blush Pink.

3. Smudge lighter areas of petal with a dry cotton swab. Wash with Bestine and a no. 6 brush.

4. Layer Light Purple Pink (Polychromos), Process Red. Dab with Bestine and a no. 4 brush.

5. Layer Apple Green, Spring Green, Chartreuse, Yellow Chartreuse. Layer the area between pistils with Cream. Then smudge lighter areas of petal with dry cotton swab. Add variegations with True Green (Verithin). Dab with Bestine and a no. 4 brush.

6. Layer Cool Grey 50%. Then burnish a small area in center with Dark Green.

7. Layer green area with Henna. Dab with Bestine and a no. 4 brush.

8. Layer Goldenrod (Verithin). Burnish pistil tips with Spanish Orange (Verithin).

STEM AND LEAVES

9. Layer Grass Green, Olive Green

10. Burnish with Cool Grey 10%. Sharpen edges with Olive Green (Verithin).

aster *By Terry Sciko*

COLOR PALETTE

(The flower is painted on Crescent mat board, Williamsburg Green)

White

Imperial Violet

Black Grape

Lavender

Lilac

Greyed Lavender

Yellowed Orange

Hot Pink

Cream

1. Lay out with White.

2. Layer highlights with White.

3. Layer shadows with Imperial Violet, Black Grape.

4. Layer Lavender, Lilac. Burnish with cheesecloth. Then layer with Greyed Lavender. Repeat steps 2 and 3.

5. Layer center petals with Yellowed Orange. Burnish with White.

6. Lightly layer base of petals with Hot Pink. Lightly burnish with Greyed Lavender.

7. Burnish center petals with Cream.

begonia

COLOR PALETTE

Cool Grey 10%	Magenta	French Grey 50%	Deep Cobalt Green (Polychromos)
Cool Grey 30%	Carmine Red	French Grey 90%	Olive Green
Spanish Orange	White	Tuscan Red	Cream
Sunburst Yellow	Crimson Red (Verithin)	Terra Cotta	Terra Cotta (Verithin)
Crimson Red	French Grey 10%		

Reference Photo

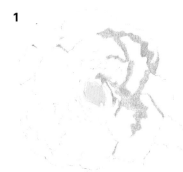

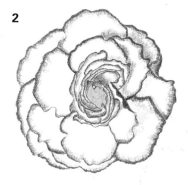

PETALS

1. Layer Cool Grey 30% in shadow areas. Wash with Bestine and a cotton swab. Layer Spanish Orange, Sunburst Yellow in center. Wash with Bestine and a cotton swab.

2. Lightly layer Crimson Red, Magenta, Carmine Red to edges of petals, using short perpendicular strokes. Layer Cool Grey 30% in shadow areas. Layer folds with Cool Grey 10%.

3. Carefully wash petals with Bestine and a cotton swab, using strokes perpendicular to the edge of the petal and dragging the nearly dry cotton swab toward the center of the flower.

4. Burnish shadow areas with White or Cool Grey 10%. Sharpen edges with Crimson Red (Verithin). Layer shadow areas at the center with French Grey 50%. Burnish with Spanish Orange, Sunburst Yellow. Burnish shadow areas with French Grey 10%.

Download free bonus materials at **Artistsnetwork.com/Creating-Radiant-Flowers-In-Colored-Pencil**

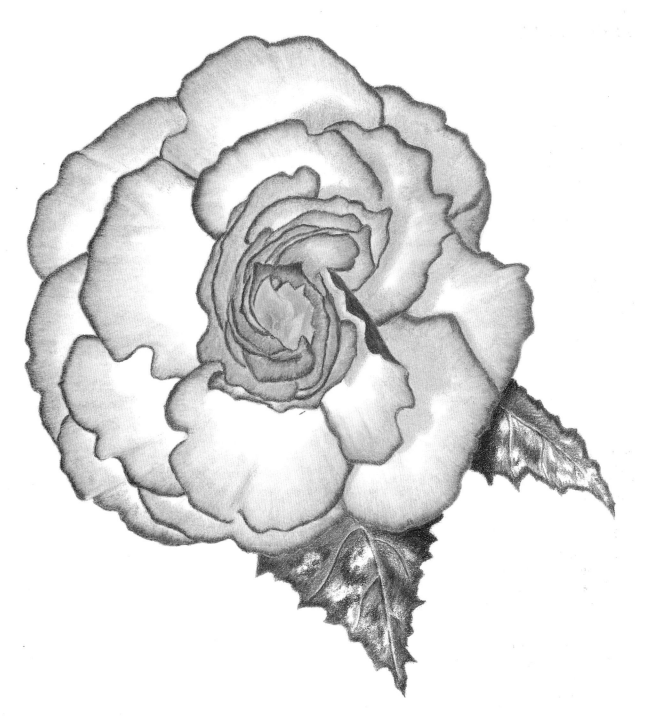

LEAVES

5. Layer shadows with Tuscan Red. Layer edge of leaf with Terra Cotta, Magenta.

6. Layer random shadows with French Grey 90%.

7. Randomly layer Deep Cobalt Green (Polychromos), Olive Green, leaving highlights free of color.

8. Lightly burnish lighter values with Cream, darker values with Deep Cobalt Green (Polychromos) and Olive Green. Sharpen edges with Terra Cotta (Verithin).

bird of paradise

COLOR PALETTE

Pumpkin Orange	French Grey 20%	Spanish Orange	Light Umber
Pale Vermilion	French Grey 50%	Orange (Verithin)	Dark Green
Dark Cadmium Orange (Polychromos)	Cream	Black Grape	Olive Green
French Grey 10%	Orange	Violet	Olive Green (Verithin)
	White	Violet (Verithin)	

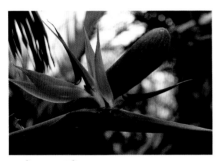

Reference Photo

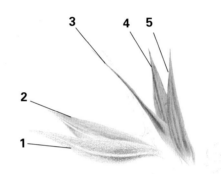

ORANGE PETALS

1. Layer Pumpkin Orange, Pale Vermilion, Dark Cadmium Orange (Polychromos), Orange. Layer lower portion with French Grey 10%.

2. Burnish lower portion with Cream.

3. Lightly burnish with Pale Vermilion, Dark Cadmium Orange (Polychromos), Orange.

4. Burnish all but the lower portion with White.

5. Burnish with Pale Vermilion, Dark Cadmium Orange (Polychromos), Orange, Spanish Orange. Sharpen edges with Orange (Verithin).

VIOLET PETALS

6. Layer Black Grape, Violet.

7. Burnish with White.

8. Burnish Black Grape, Violet. Burnish lighter areas with White. Sharpen edges with Violet (Verithin).

9. (See finished painting.) Burnish end of petal with Light Umber, dragging violet into area.

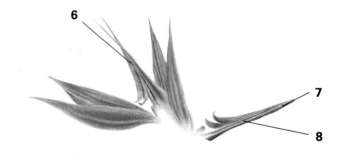

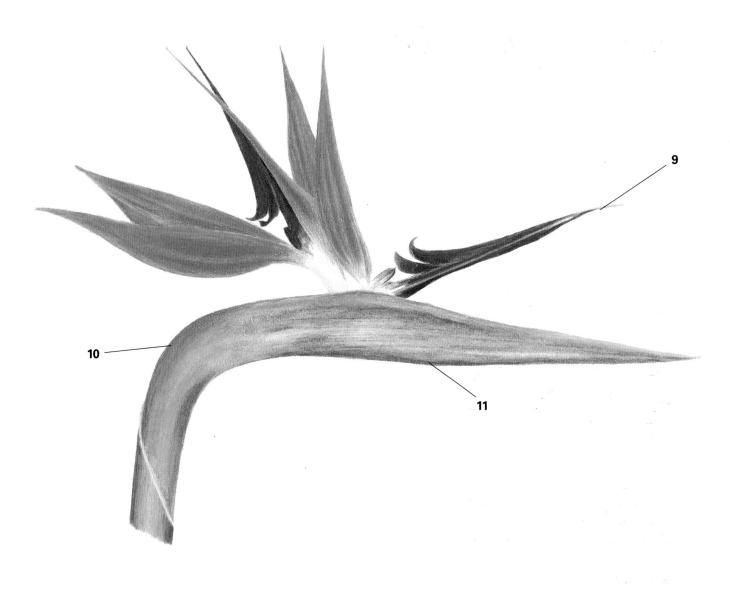

BASE AND STEM

10. Layer darkest values in both orange and green areas with French Grey 50%. Wash with Bestine and a cotton swab. Then layer French Grey 20%, Pumpkin Orange, Pale Vermilion, Dark Cadmium Orange (Polychromos), Orange. Wash with Bestine and a cotton swab. Repeat layering the last sequence of colors and washing as necessary.

11. Layer Dark Green, Olive Green, French Grey 20%. Wash with Bestine and a cotton swab, dragging color into orange areas. Lightly burnish Dark Green, Olive Green, French Grey 20%. Repeat layering, washing and dragging as necessary. Sharpen edges with Olive Green (Verithin) and Orange (Verithin).

cactus flower

COLOR PALETTE

Deco Yellow

Jasmine

Sunburst Yellow

Goldenrod

Yellow Ochre

Pumpkin Orange

Crimson Red

Scarlet Lake

Poppy Red

Pale Geranium Lake
(Polychromos)

Process Red

Orange (Verithin)

Crimson Red (Verithin)

Magenta

Light Purple Pink
(Polychromos)

Black Grape

Violet

Dahlia Purple

Mulberry

Parma Violet

Lilac

Lavender

Greyed Lavender

Cool Grey 20%

Cool Grey 50%

White

Process Red (Verithin)

Parma Violet (Verithin)

White (Verithin)

Warm Grey 90%

Chrome Oxide Green
(Polychromos)

Olive Black (Pablo)

Olive Green

Lime Peel

Olive Green (Verithin)

Indian Red (Polychromos)

Magenta (Verithin)

Warm Grey 20% (Verithin)

True Green (Verithin)

CENTER

1. Layer upper center with Deco Yellow, Jasmine. Wash with Bestine and a cotton swab. Layer lower center with Sunburst Yellow. Wash with Bestine and a cotton swab.

2. Burnish upper center with Goldenrod, Yellow Ochre. Randomly erase small areas with sharpened imbibed eraser strip and electric eraser. Dab with Bestine and a cotton swab.

3. Layer Pumpkin Orange, Crimson Red, Scarlet Lake, Poppy Red, Pale Geranium Lake (Polychromos), Process Red. Burnish with Orange (Verithin).

4. Layer Crimson Red, Poppy Red. Burnish with Pale Geranium Lake (Polychromos). Sharpen edges with Crimson Red (Verithin).

1

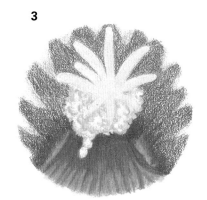

2

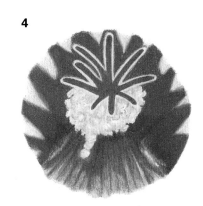

3

4

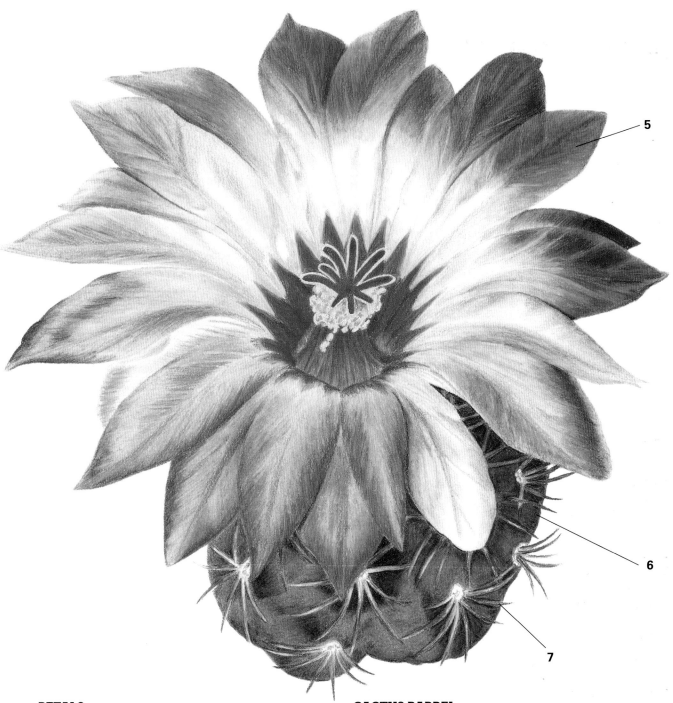

PETALS

5. Note that each individual petal does not have all the colors listed in this step because the color palette varies from petal to petal.

Layer Process Red, Magenta, Light Purple Pink (Polychromos), Black Grape, Violet, Dahlia Purple, Mulberry, Parma Violet, Lilac, Lavender, Greyed Lavender, Cool Grey 50%, 20%. Burnish with White. Repeat this entire step as necessary. Sharpen edges with Process Red (Verithin), Parma Violet (Verithin) or White (Verithin).

CACTUS BARREL

6. Layer dark values with Warm Grey 90%. Layer Chrome Oxide Green (Polychromos), Olive Black (Pablo), Olive Green, leaving spines free of color. Burnish dark values with Olive Green. Burnish light values with Lime Peel. Sharpen edges with Olive Green (Verithin).

SPINES

7. Randomly layer Indian Red (Polychromos), Magenta (Verithin). Burnish dark areas with Warm Grey 20% (Verithin). Burnish light areas with White (Verithin). Repeat step as necessary. Sharpen inside areas with Olive Green (Verithin) or True Green (Verithin). Sharpen outside areas with White (Verithin)

california poppy

COLOR PALETTE

Goldenrod

Pumpkin Orange

Yellow Ochre

Sunburst Yellow

Spanish Orange

Yellowed Orange

Dark Cadmium Orange (Polychromos)

Spanish Orange (Verithin)

Olive Green (Verithin)

Lime Peel

Dark Umber

Terra Cotta (Verithin)

White (Verithin)

Orange (Verithin)

Dark Green

Olive Green

True Green

Cool Grey 10%

True Green (Verithin)

PETALS

1. Layer shadow areas with Goldenrod, Pumpkin Orange. Layer Yellow Ochre as shown.

2. Wash with Bestine and a no. 8 brush.

3. Layer a gradation of color, starting from the edge and working to the center of the petal, with Sunburst Yellow, Spanish Orange, Yellowed Orange, Dark Cadmium Orange (Polychromos). Leave center and highlight area free of color. Drag small amount of color into highlight area with a dry cotton swab.

4. Wash with Bestine and a no. 8 brush.

5. Lightly burnish with Sunburst Yellow, Spanish Orange, Yellowed Orange, Dark Cadmium Orange (Polychromos), except areas above and below highlight. Repeat until paper surface is completely covered. Sharpen edges with Spanish Orange (Verithin).

CENTER

6. Layer Olive Green (Verithin), Lime Peel. Wash with Bestine and a very small brush.

7. Layer with Dark Umber. Burnish and sharpen edges with Terra Cotta (Verithin).

8. Using a new #11 craft knife blade, gently scrape color away. Burnish with White (Verithin), Spanish Orange (Verithin). Sharpen edges and decrease width with Orange (Verithin) or Terra Cotta (Verithin).

LEAVES AND STEMS

9. Layer dark values with Dark Green. Layer Olive Green, True Green, Lime Peel.

10. Burnish with Cool Grey 10%, except darkest values.

11. Burnish with True Green, Lime Peel. Sharpen edges with True Green (Verithin).

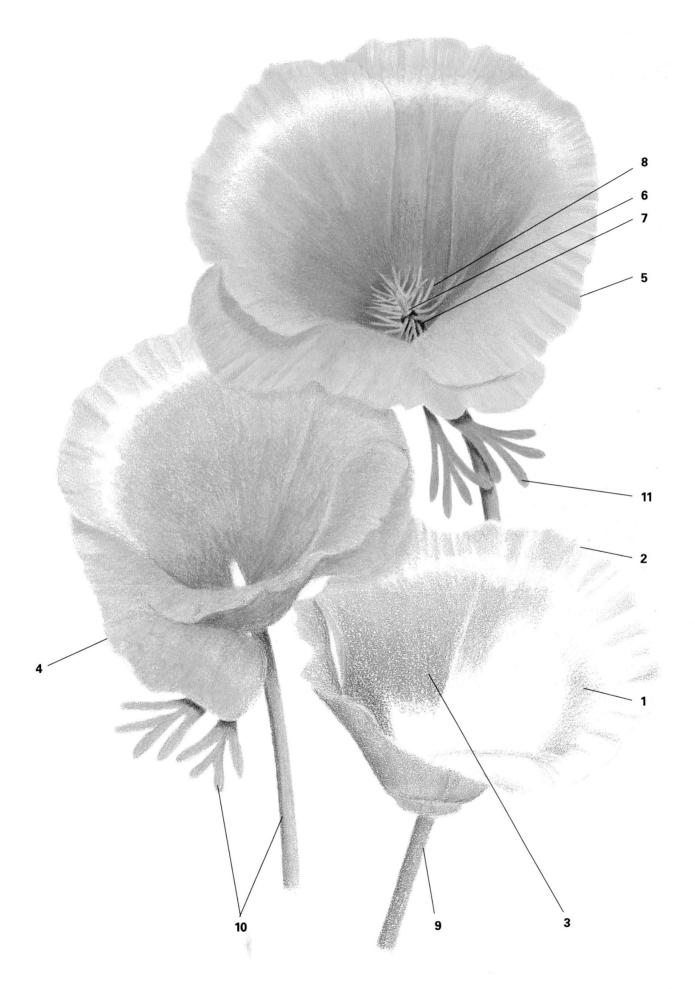

calla lily *By Susan L. Brooks*

COLOR PALETTE

(All colors are Derwent WS unless otherwise noted.)

Primrose Yellow
Pink Madder Lake
Rose Pink
Rose Madder Lake

Magenta
Terracotta
Spectrum Orange
Mulberry (Prismacolor)
Dark Purple (Prismacolor)
Imperial Purple

Middle Chrome
Light Violet
Blue Violet Lake
Smalt Blue
White (Prismacolor)
Emerald Green

Delft Blue
Peacock Green (Prismacolor)
True Green (Prismacolor)
Olive Green
Cedar Green
Raw Sienna

FLOWER

1. Layer Primrose Yellow, Pink Madder Lake, leaving rim free of pigment. Lightly burnish with Rose Pink.

2. Layer Rose Madder Lake, Magenta.

3. Layer stamen with Primrose Yellow, Terracotta, Spectrum Orange, using a diagonal crosshatch stroke.

4. See the flower on the lower right. Layer outside with Mulberry (Prismacolor), Dark Purple (Prismacolor).

5. Lightly burnish stamen with Imperial Purple.

6. Lightly burnish inside with Mulberry (Prismacolor).

7. Burnish edge of rim with Middle Chrome.

8. Layer shadow areas of rim with Light Violet. Blue Violet Lake, Smalt Blue.

9. Burnish rim with White (Prismacolor).

LEAVES

10. Layer front with Emerald Green. Burnish with colorless blender, leaving edges free of color. Layer shadows with Delft Blue.

11. Burnish with Emerald Green, Peacock Green (Prismacolor), True Green (Prismacolor).

12. Layer back with Olive Green. Burnish with colorless blender, leaving edges free of color.

13. Layer dark values with Cedar Green. Lightly burnish Olive Green, Raw Sienna.

14. Lightly burnish edges with Middle Chrome, Primrose Yellow.

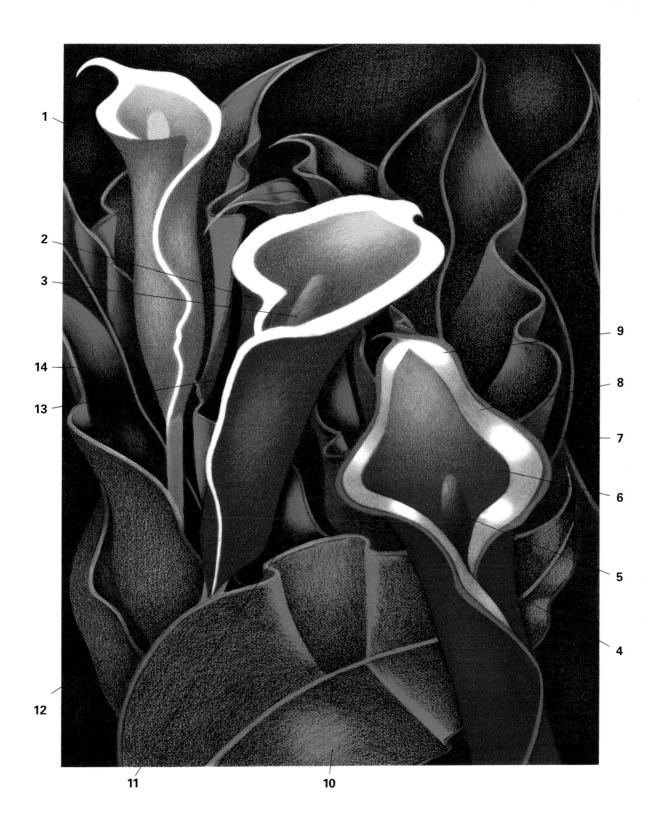

camellia *By Edna Henry*

COLOR PALETTE

(All colors are Polychromos unless otherwise stated.)

Light Flesh
Rose Pink (Derwent WS)
Dark Flesh
Rose Carmine
Pink Carmine

Pink Madder Lake
Light Purple Pink
Burnt Carmine
Magenta
Scarlet Red
Light Cadmium Red

Cadmium Orange
Cadmium Yellow
Earth Green Yellowish
Bluish Turquoise
Pine Green
Hooker's Green

Sky Blue (Derwent Artists)
Red-Violet
May Green
Copenhagen Blue
 (Prismacolor)
Dahlia Purple (Prismacolor)

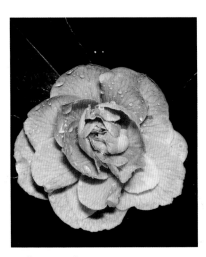

Reference Photo

1. Layer Light Flesh, Rose Pink (Derwent WS).

2. Layer Dark Flesh, adding more layers in shadow areas. Layer Rose Carmine.

3. Layer flower with Pink Carmine, Pink Madder Lake, LIght Purple Pink, Burnt Carmine, Magenta, Scarlet Red, Light Cadmium Red, Cadmium Orange.

4. Layer Cadmium Yellow, Earth Green Yellowish

5. Layer Bluish Turquoise, Pine Green.

6. Layer Hooker's Green, Sky Blue (Derwent Artists), Red-Violet, May Green, Copenhagen Blue (Prismacolor), Dahlia Purple (Prismacolor).

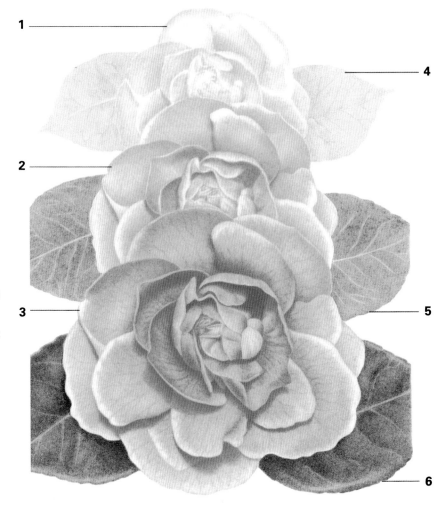

carnation *By Terry Sciko*

COLOR PALETTE

(The flower is painted on Bockingford tinted drawing paper.)

Celadon Green

Poppy Red

White

Black Grape

Indigo Blue

Dark Green

Periwinkle

1. Layer dark values with Celadon Green.

2. Layer variegations with Poppy Red.

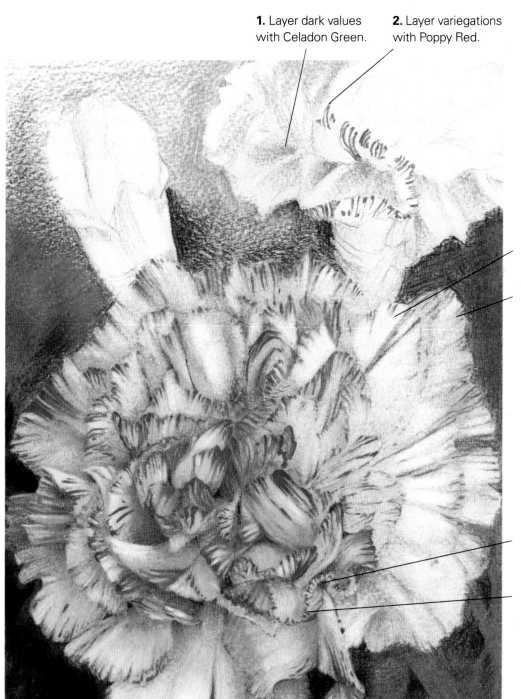

3. Burnish with cheesecloth. Lift highlights with kneaded eraser.

4. Layer highlights with White.

5. Layer shadows with Black Grape, Indigo Blue, Dark Green, Celadon Green, Periwinkle.

6. Sharpen variegations with Poppy Red.

chrysanthemum

COLOR PALETTE

Mulberry	Black	Tuscan Red	Deep Cobalt Green (Polychromos)
Magenta	Black (Verithin)	Crimson Lake	Olive Green
Process Red	Dark Brown (Verithin)	Poppy Red	Apple Green
Yellow Ochre	Cool Grey 10%	White	Cream
Sunburst Yellow	Cool Grey 20%	Process Red (Verithin)	Olive Green (Verithin)
Dark Umber	Goldenrod		

CENTER

1. Lightly layer Mulberry, Magenta, Process Red. Wash with Bestine and cotton swab, dragging color into lighter surrounding area. Then layer Yellow Ochre, Sunburst Yellow. Wash with Bestine and a cotton swab.

2. Lightly layer with Dark Umber and Black using small circular strokes.

3. Burnish with Dark Umber and Black. Sharpen edges with Black (Verithin) and Dark Brown (Verithin).

4. Burnish, using small circular strokes, with Dark Umber and Black. Sharpen edges with Black (Verithin) and Dark Brown (Verithin).

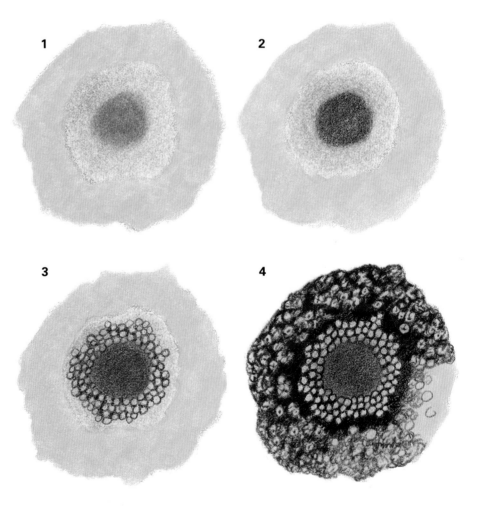

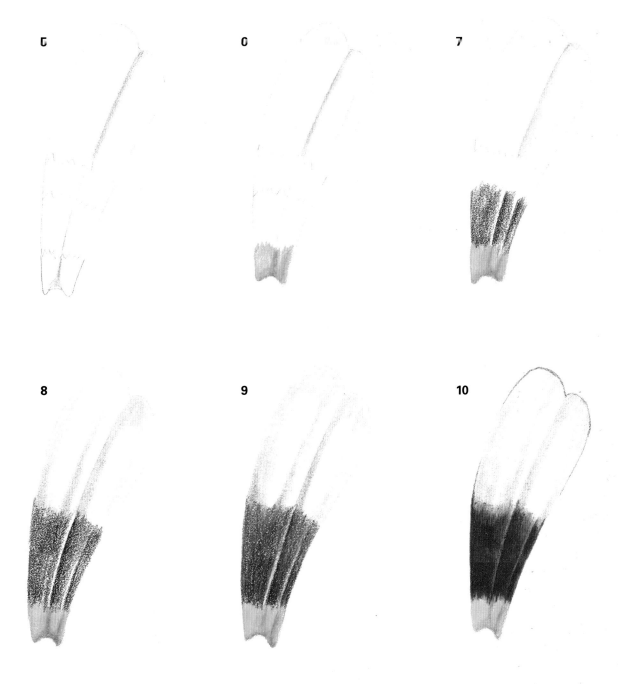

PETALS

5. Layer Cool Grey 20%, 10%. Wash with Bestine and a cotton swab.

6. Burnish yellow area with Goldenrod, Sunburst Yellow. Wash with Bestine and a no. 4 brush.

7. Layer red area with Tuscan Red, Crimson Lake, Poppy Red.

8. Layer magenta area with Mulberry, Magenta, Process Red. Drag the color onto white area with dry cotton swab.

9. Burnish red and magenta areas with White.

10. Burnish red area with Poppy Red and magenta area with Process Red. Repeat steps 9 and 10 as necessary. Then burnish red and yellow border with Sunburst Yellow and lightly layer edges with Process Red (Verithin).

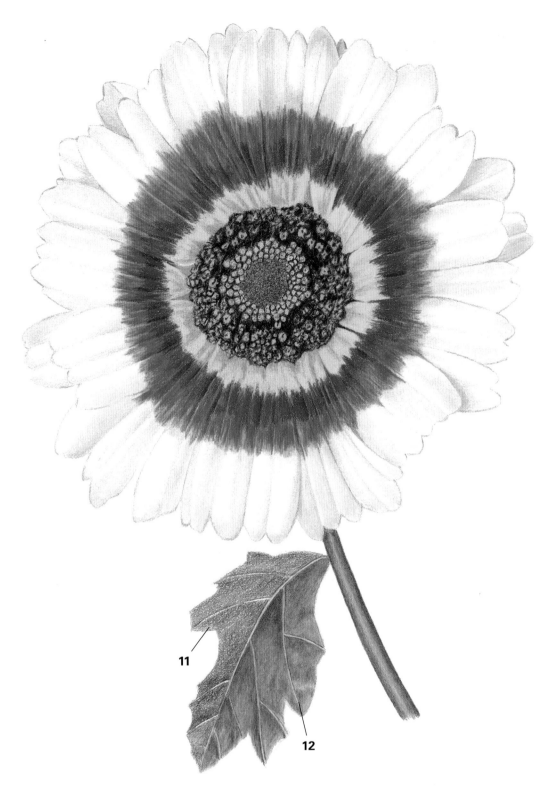

LEAF AND STEM

11. Layer Deep Cobalt Green (Polychromos), Olive Green, Apple Green.

12. Burnish with Cream. Then burnish with Olive Green, Apple Green. Sharpen edges with Olive Green (Verithin).

ANOTHER
chrysanthemum

COLOR PALETTE

Sunburst Yellow

Chartreuse

Olive Green (Verithin)

True Green (Verithin)

Cool Grey 10%

Cool Grey 30%

Cool Grey 50%

Magenta

Process Red

Hot Pink

White

White (Verithin)

Deco Pink (Verithin)

Process Red (Verithin)

Magenta (Verithin)

Deep Cobalt Green
(Polychromos)

Olive Green

Apple Green

Cream

CENTER

1. Layer Sunburst Yellow. Wash with Bestine and a cotton swab. Then layer Chartreuse on top, leaving yellow edge. Wash with Bestine and a cotton swab. Draw circles in chartreuse area with Olive Green (Verithin) and True Green (Verithin) on yellow edge.

PETALS

2. Layer shadows with Cool Grey 50%, 30%, or 10% (depending on value). Wash with Bestine and a no. 4 brush.

3. Layer Magenta, Process Red, Hot Pink.

4. Smudge with dry cotton swab, leaving light areas free of color.

5. Wash with Bestine and a no. 4 brush.

6. Lightly burnish with White.

7. Layer Magenta, Process Red, Hot Pink.

8. Burnish with White (Verithin). Sharpen edges with Deco Pink (Verithin), Process Red (Verithin), or Magenta (Verithin), depending on edge color.

LEAF AND STEM

9. Layer Deep Cobalt Green (Polychromos), Olive Green, Apple Green. Wash with Bestine and a no. 4 brush.

10. Lightly burnish with Cool Grey 10%, Cream. Dab with Bestine and a no. 4 brush. Sharpen edges with True Green (Verithin) or Olive Green (Verithin), depending on the edge color.

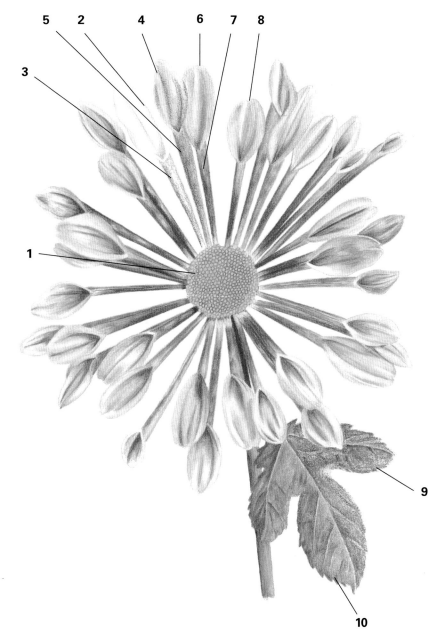

ONE MORE
chrysanthemum

COLOR PALETTE

Sienna Brown	Dark Cadmium Orange (Polychromos)	White	Dark Green
Hazel (Pablo)	Cadmium Orange (Polychromos)	Orange (Verithin)	Olive Green
Pumpkin Orange	Yellowed Orange	Cool Grey 10%	Lime Peel
Pale Vermilion		Cool Grey 90%	Olive Green (Verithin)

PETALS

1. Layer Sienna Brown, Hazel (Pablo), Pumpkin Orange, Pale Vermilion.

2. Layer Dark Cadmium Orange (Polychromos), Cadmium Orange (Polychromos).

3. Layer Yellowed Orange. Leave highlights free of color.

4. Smudge lightly with dry cotton swab.

5. Lightly burnish with White.

6. Burnish dark values with Hazel (Pablo), Pumpkin Orange. Burnish lighter values with Yellowed Orange. Repeat steps 5 and 6 as necessary. Sharpen edges with Orange (Verithin).

7. Layer darkest values of leaf and stem with Cool Grey 90%. Layer Dark Green, Olive Green, Lime Peel. Leave highlights free of color. Burnish lightly with Cool Grey 10%. Burnish with Olive Green, Lime Peel. Sharpen edges with Olive Green (Verithin).

1

2

3

4 & 5

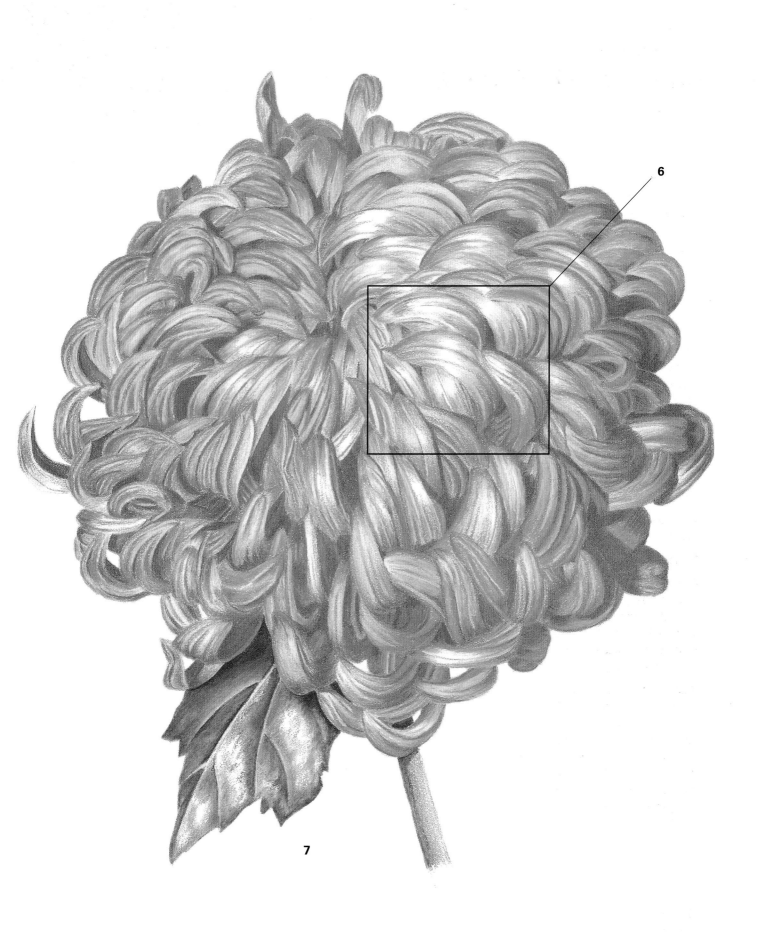

6

7

cineraria

COLOR PALETTE

Spanish Orange	White	Cool Grey 30%	Olive Green
Sunburst Yellow	Magenta (Verithin)	Lavender	Emerald Green (Polychromos)
Tuscan Red	Tuscan Red (Verithin)	Carmine Red	Spring Green
Magenta	Cool Grey 10%	Hot Pink	Grass Green (Verithin)
Process Red	Cool Grey 20%	Grass Green	True Green (Verithin)

CENTER

1. Layer Spanish Orange. Burnish with Sunburst Yellow.

2. Layer Tuscan Red, Magenta, Process Red.

3. Dab with Bestine and a cotton swab.

4. Burnish with White.

5. Burnish with Tuscan Red, Process Red. Repeat steps 3 and 4. Sharpen edges with Magenta (Verithin) or Tuscan Red (Verithin).

PETALS

6. Layer white area in center with Cool Grey 30%, 10%, leaving highlights free of color.

7. Layer dark values with Lavender. Layer Process Red, Carmine Red, Hot Pink.

8. Wash with Bestine and a cotton swab.

9. Burnish with White, including gray shadows from step 6. Don't burnish darkest values or edge adjacent to white area.

10. Lightly burnish with Process Red, Carmine Red. Burnish with Hot Pink. Sharpen edges with Magenta (Verithin).

LEAVES AND STEM

11. Layer Grass Green, Olive Green, Emerald Green (Polychromos), Spring Green.

12. Burnish with Cool Grey 20%. Lightly burnish Grass Green, Olive Green, Emerald Green (Polychromos). Burnish with Spring Green, Olive Green. Lightly erase stem with kneaded eraser. Sharpen edges with Grass Green (Verithin), True Green (Verithin).

Reference Photo

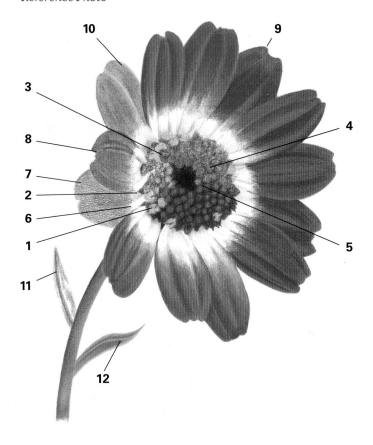

crocus

COLOR PALETTE

Cool Grey 10%	Lilac	Sunburst Yellow	French Grey 70%
Cool Grey 20%	White	Goldenrod	Deep Cobalt Green
Cool Grey 50%	Parma Violet (Verithin)	Spanish Orange	(Polychromos)
Parma Violet	Black Grape	French Grey 10%	Olive Green
Lavender	Violet (Verithin)	French Grey 20%	Olive Green (Verithin)

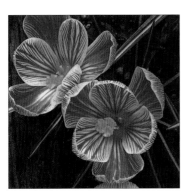

Reference Photo

PETALS

Note: there are two different types of petal, one with clear variegations (petal A), the other with color between variegations (petal B). The color palettes are the same, but the petals are rendered somewhat differently.

1. Layer center with Cool Grey 50%. Wash with Bestine and a cotton swab. Layer inside of petals and edge of petal where it folds over with Cool Grey 20%. Be careful to leave white edge at the end of each petal free of color. Wash with Bestine and a cotton swab.

2. Layer variegations with Parma Violet, Lavender, Lilac on inside of petal only. Petal A: Smudge with dry cotton swab into lighter areas next to variegations. Petal B: Lightly layer Parma Violet, Lavender. Smudge with a dry cotton swab. Then wash with a small amount of Bestine and a cotton swab.

3. Burnish lighter, smudged areas of petal A with Cool Grey 10%, and randomly burnish variegations with White, using light pressure. Randomly burnish petal B with Parma Violet, Lavender, Cool Grey 20%.

4. Draw thinner variegations with Parma Violet (Verithin). Burnish folded-over area of petal with Lavender, leaving white edge free of color. Draw veins in center of large variegations with Black Grape, Violet (Verithin).

PISTIL AND STAMEN

5. Layer entire area with Sunburst Yellow. Wash with Bestine and a cotton swab. Burnish with Goldenrod, Spanish Orange.

LEAVES

6. Layer French Grey 70%, 10%, 20%.

7. Burnish all but the center area with Deep Cobalt Green (Polychromos), Olive Green. Drag green into light center area by smudging with dry cotton swab. Sharpen edges with Olive Green (Verithin).

POLLEN

8. Erase small areas with sharpened imbibed eraser strip in electric eraser, . Then burnish with Spanish Orange, Sunburst Yellow.

columbine

COLOR PALETTE

Sunburst Yellow	Parma Violet (Verithin)	Parma Violet	Tuscan Red
Goldenrod	White	Lilac	Olive Green
Cool Grey 20%	Spanish Orange (Verithin)	Lavender	Lime Peel
Warm Grey 20% (Verithin)	Violet	White (Verithin)	Tuscan Red (Verithin)
			Olive Green (Verithin)

CENTER

1. Burnish Sunburst Yellow. Burnish edges with Goldenrod.

2. Layer Cool Grey 20%. Wash with Bestine and a no. 6 brush. Layer Sunburst Yellow. Wash with Bestine and a no. 6 brush. Lightly draw lines with Warm Grey 20% (Verithin), Goldenrod, Parma Violet (Verithin).

YELLOW PETALS

3. Layer dark values with Goldenrod. Wash with Bestine and a no. 8 brush.

4. Layer Sunburst Yellow. Lightly burnish with White, except darkest values. Burnish with Sunburst Yellow. Repeat burnishings with White and Sunburst Yellow as necessary. Sharpen edges with Spanish Orange (Verithin).

LAVENDER PETALS

5. Layer dark values with Violet. Layer Parma Violet, Lilac, Lavender.

6. Burnish with White, except darkest values. Burnish dark values with Parma Violet. Burnish with Lilac, Lavender. Repeat as necessary. Sharpen edges with Parma Violet (Verithin) or White (Verithin).

LAVENDER AND YELLOW PETALS

7. Layer Goldenrod, Sunburst Yellow. Wash with Bestine and a cotton swab. Lightly layer Lilac, Lavender into yellow area. Wash with Bestine and a no. 4 brush. Layer dark values with Violet, Parma Violet. Then lightly burnish with White, except darkest values. Now lightly burnish with Lilac, Sunburst Yellow. Repeat, starting with Violet and Parma Violet, until smooth gradation is achieved.

STEM

8. Layer Tuscan Red, Olive Green, Lime Peel. Burnish with White. Lightly burnish with Tuscan Red, Olive Green, Lime Peel. Repeat burnishing as necessary. Sharpen edges with Tuscan Red (Verithin) and Olive Green (Verithin).

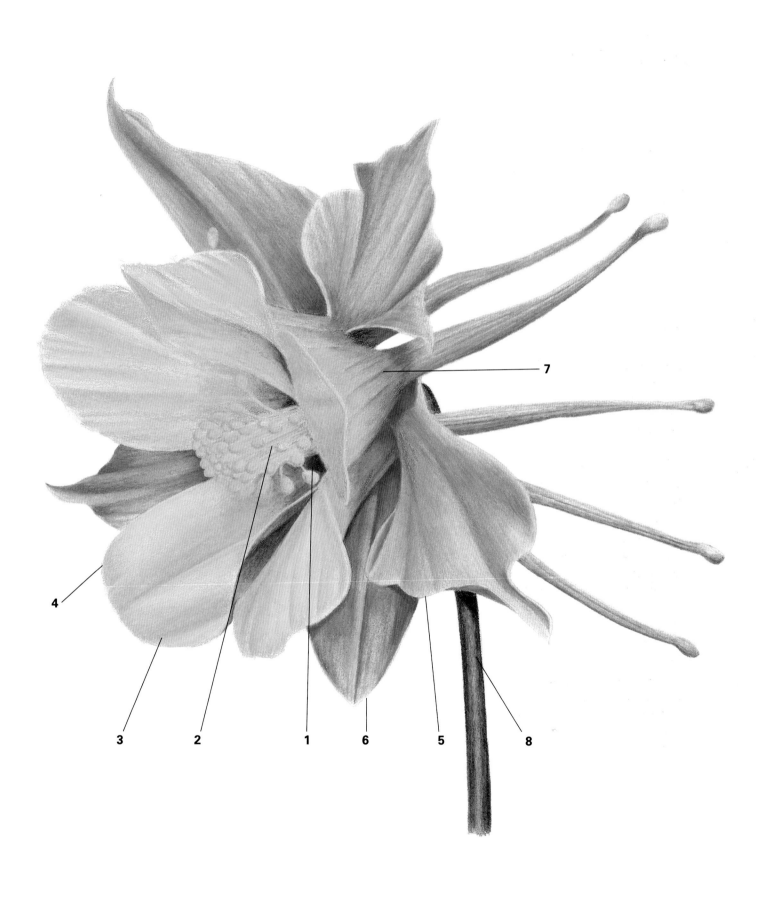

7

4

3 2 1 6 5 8

daffodil *By Kristy Kutch*

COLOR PALETTE

(All colors are Derwent Artists unless otherwise noted.)

Chocolate

Naples Yellow

Primrose Yellow

Deep Cadmium

Gold

Jade Green

Gold (Verithin)

Dark Brown (Verithin)

Indigo Blue (Verithin)

Cream (Prismacolor)

Slate Grey (Prismacolor)

Juniper Green

White (Prismacolor)

Indigo Blue (Prismacolor)

Dark Green (Prismacolor)

Green Grey

YELLOW PETALS

1. Layer darkest values with Chocolate. Layer Naples Yellow, Primrose Yellow, Deep Cadmium, Gold, Jade Green. Define edges with Gold (Verithin), Dark Brown (Verithin), Indigo Blue (Verithin).

2. Burnish with Cream (Prismacolor). Repeat steps 1 and 2 as necessary. Sharpen edges with Chocolate.

WHITE PETALS

3. Layer darkest values/shadows with Slate Grey (Prismacolor), Indigo Blue (Verithin). Lightly layer Jade Green, Juniper Green, Primrose Yellow, leaving lightest values free of color.

4. Burnish with White (Prismacolor).

5. Lightly layer shadows with Juniper Green, Jade Green. Lightly layer Primrose Yellow, Deep Cadmium. Repeat steps 4 and 5 as necessary. Sharpen edges with Juniper Green or Indigo Blue (Verithin).

LEAVES AND STEM

6. Layer darker values with Indigo Blue (Prismacolor), Dark Green (Prismacolor). Layer middle values with Juniper Green. Layer light values/stems with Green Grey.

7. Impress veins with 7H graphite pencil and drafting or tracing paper. Lightly burnish with Cream (Prismacolor). Lightly burnish shadows with Indigo Blue (Prismacolor). Lightly burnish Juniper Green, Dark Green (Prismacolor). Repeat burnishing in same order as necessary. Sharpen edges with Indigo Blue (Verithin).

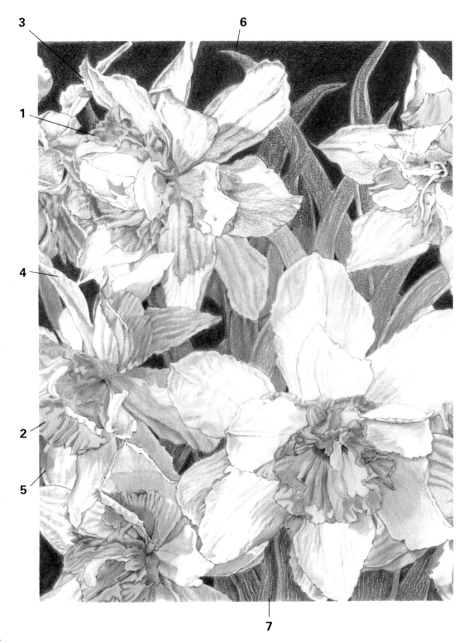

dahlia

COLOR PALETTE

Goldenrod (Verithin)

Spanish Orange

Sunburst Yellow

Hazel (Pablo)

Crimson Red

Pale Geranium Lake (Polychromos)

Poppy Red

Scarlet Lake

Dark Cadmium Yellow (Polychromos)

Crimson Red (Verithin)

Spanish Orange (Verithin)

Cool Grey 10%

Cool Grey 90%

Olive Green

Apple Green

Cream

Olive Green (Verithin)

Tuscan Red

Light Umber

Tuscan Red (Verithin)

CENTER

1. Define dark values by burnishing with Goldenrod (Verithin).

2. Layer Spanish Orange, Sunburst Yellow. Dab with Bestine and a no. 4 brush.

3. Redefine dark values with Hazel (Pablo). With sharpened imbibed eraser strip in an electric eraser, erase highlight areas. Dab with Bestine and a no. 4 brush.

PETALS

4. Layer Sunburst Yellow.

5. Wash with Bestine and a cotton swab.

6. Layer Crimson Red, Pale Geranium Lake (Polychromos), Poppy Red.

7. Lightly burnish with Sunburst Yellow.

8. Burnish with Scarlet Lake. Lightly burnish with Dark Cadmium Yellow (Polychromos) where red meets the yellow area. Sharpen red edges with Crimson Red (Verithin) and yellow edges with Spanish Orange (Verithin).

LEAF

9. Layer dark values with Cool Grey 90%. Layer Olive Green, Apple Green. Burnish with Cool Grey 10%.

10. Layer Olive Green, Apple Green. Burnish with Cream, Olive Green (dark values), Apple Green (light values). Sharpen edges with Olive Green (Verithin).

STEM

11. Layer Cool Grey 90%, Olive Green, Tuscan Red, Light Umber. Burnish with Cool Grey 10%. Lightly burnish Cool Grey 90%, Olive Green, Tuscan Red, Light Umber. Sharpen edges with Olive Green (Verithin) or Tuscan Red (Verithin).

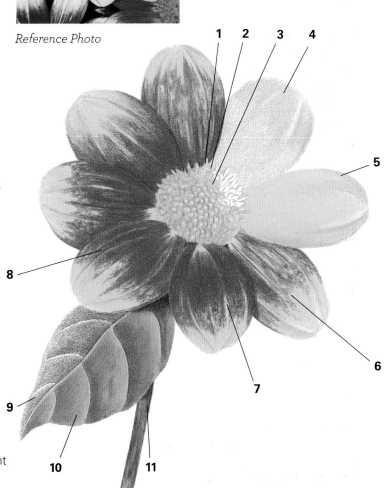

Reference Photo

ANOTHER
dahlia

COLOR PALETTE

Sunburst Yellow

Olive Green

Cool Grey 70%

Lavender

Mulberry

Magenta

White

Magenta (Verithin)

White (Verithin)

Deep Cobalt Green
 (Polychromos)

Apple Green

Cream

Apple Green (Verithin)

Olive Green (Verithin)

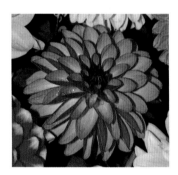

Reference Photo

PETALS

1. (see finished flower) Layer Sunburst Yellow. Wash with Bestine and a no. 4 brush. Layer Olive Green in areas shown only. Wash with Bestine and a no. 2 brush.

2. Layer shadows with Cool Grey 70%. Wash with Bestine and a small brush. Layer Lavender on top. Wash with Bestine and a no. 4 bush.

3. Lightly layer Mulberry, Lavender, Magenta, leaving highlights free of color.

4. Smudge with a dry cotton swab.

5. Wash with Bestine and a small brush.

6. Lightly burnish with White.

7. Repeat steps 3 and 6 as required.

8. Layer Mulberry, Magenta.

9. Burnish with White.

10. Burnish with Mulberry, Magenta. Sharpen dark edges with Magenta (Verithin) and light edges with White (Verithin).

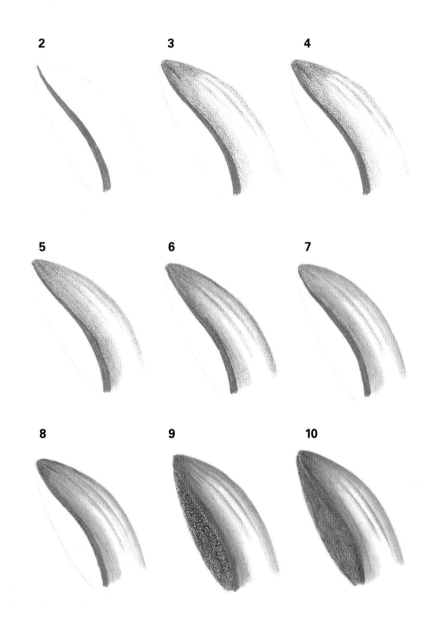

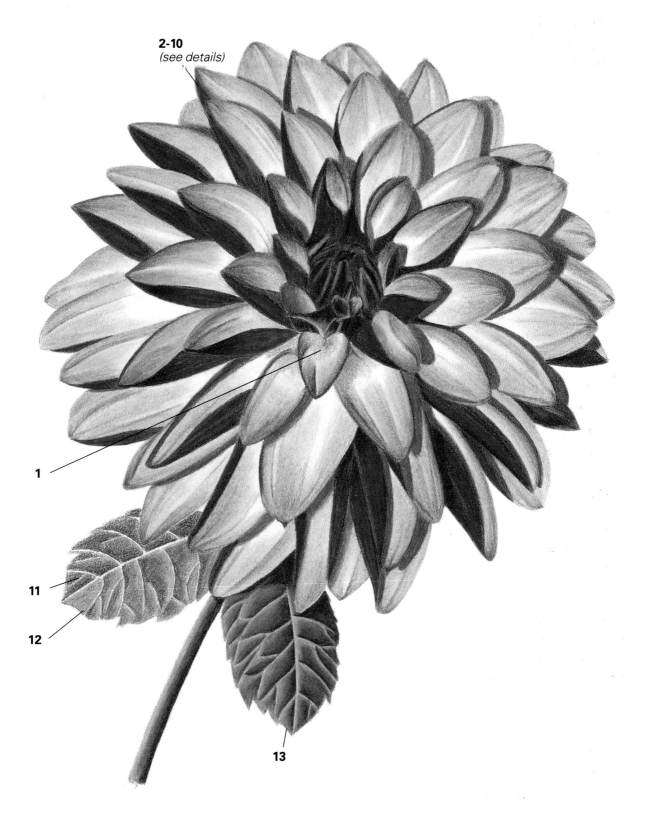

2-10
(see details)

1

11

12

13

LEAVES AND STEM

11. Layer shadows with Cool Grey 70%. Layer Deep Cobalt Green (Polychromos), Olive Green, Apple Green.

12. Lightly burnish with Cream.

13. Burnish with Olive Green, Apple Green. Repeat steps 12 and 13 as necessary. Sharpen edges with Apple Green (Verithin) or Olive Green (Verithin).

easter cactus

COLOR PALETTE

French Grey 10%
French Grey 30%
Warm Grey 20% (Verithin)
Goldenrod
Yellow Ochre
Jasmine
White
Henna

Magenta
Process Red
Poppy Red
Magenta (Verithin)
Process Red (Verithin)
Crimson Red (Verithin)
Dark Green

Grass Green
Olive Black (Pablo)
Olive Green
True Green
Green Ochre (Pablo)
Olive Green (Verithin)

PISTILS AND STAMEN

1. Layer French Grey 30%, 10%. Wash with Bestine and a no. 4 brush. Lightly burnish with French Grey 10%. Define edges with Warm Grey 20% (Verithin).

2. Layer Goldenrod, Yellow Ochre, Jasmine. Wash with Bestine and a no. 4 brush. Burnish with Jasmine, leaving some areas free of color. Burnish light values with White.

PETALS

3. Layer shadows with Henna. Layer Magenta, Process Red, Poppy Red, leaving light values and highlights free of color.

4. Smudge pigment into light areas with cotton swab, leaving highlight free of color.

5. Lightly burnish with White.

6. Lightly burnish with Magenta, Process Red, Poppy Red.

7. Burnish with White.

8. Burnish with Poppy Red. Sharpen edges with Magenta (Verithin), Process Red (Verithin), or Crimson Red (Verithin).

LEAVES

9. Layer dark values with Dark Green, Grass Green. Layer Olive Black (Pablo), Olive Green, True Green, Green Ochre (Pablo), leaving highlights free of color. Sharpen edges with Olive Green (Verithin).

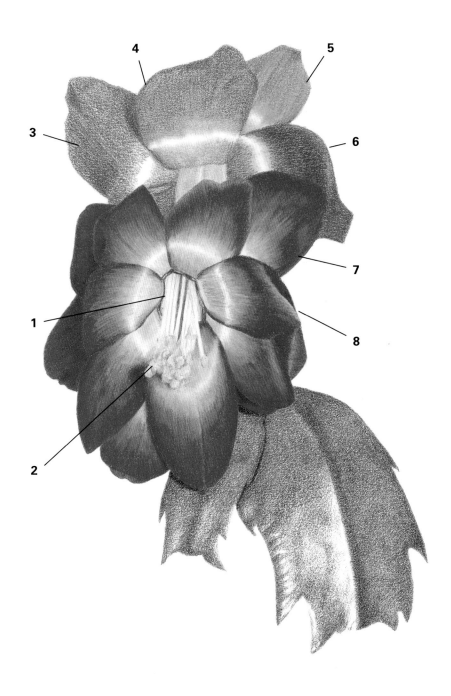

Reference Photo: flowers

Reference Photo: leaves

foxglove

COLOR PALETTE

Tuscan Red
Tuscan Red (Verithin)
Cool Grey 10%
Cool Grey 20%
Cool Grey 90%
Henna

Magenta
Process Red
Rosy Beige
Clay Rose
Pink Rose
Hot Pink

Pink
Deco Pink
White
Scarlet Lake
Crimson Red (Verithin)
Process Red (Verithin)

Deep Cobalt Green
(Polychromos)
Olive Green
Lime Peel
Olive Green (Verithin)

FLOWERS

1. Burnish spots with Tuscan Red, leaving surrounding area free of color. Sharpen edges with Tuscan Red (Verithin).

2. Burnish spots in shadow with Cool Grey 90%, Tuscan Red.

3. Layer shadows and darkest values with Tuscan Red, Henna, Magenta.

4. Layer midtone values with Process Red, Rosy Beige, Clay Rose, Pink Rose.

5. Layer Hot Pink, Pink, Pink Rose, Deco Pink.

6. Wash with Bestine and a no. 8 brush.

7. Lightly burnish with White, except shadows.

8. Burnish shadow and darkest values with Tuscan Red, Henna.

9. Burnish around spots in shadow with White.

10. Burnish darkest values on outer part of flower with Scarlet Lake.

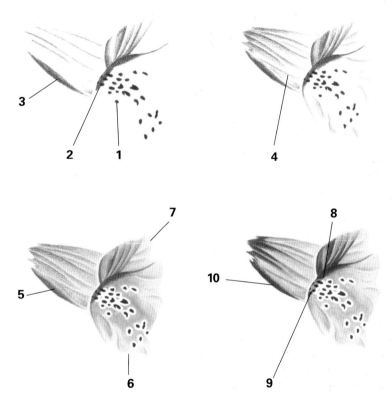

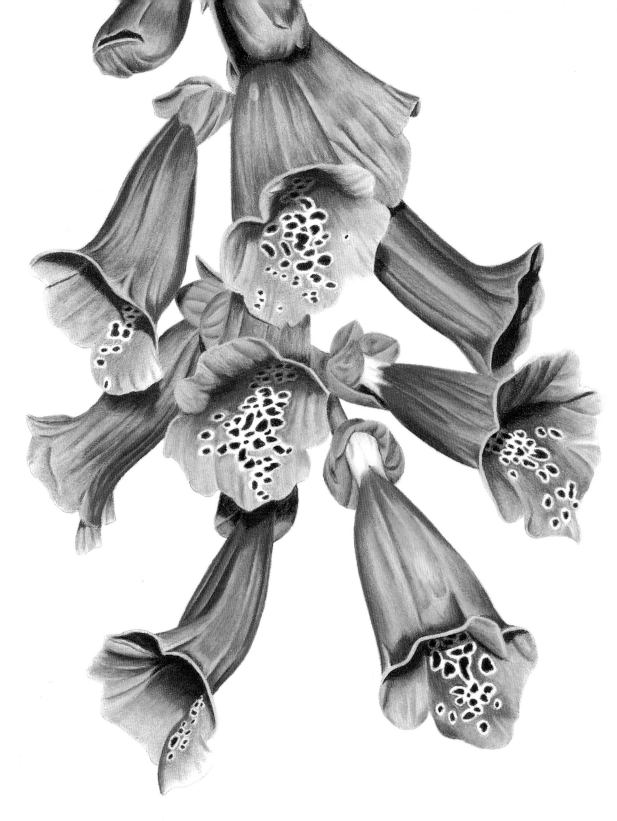

11. To finish flowers burnish with Process Red, Hot Pink, Deco Pink, White. Repeat steps 7-9 as necessary. Sharpen edges with Tuscan Red (Verithin), Crimson Red (Verithin) or Process Red (Verithin). Layer white area with Cool Grey 20%. Burnish with White, dragging color into the area and leaving some paper free of color.

LEAVES

12. Layer Cool Grey 90% (shadows only), Deep Cobalt Green (Polychromos), Olive Green, Lime Peel. Lightly burnish with Cool Grey 10% (except shadows). Layer Henna to areas as shown. Burnish with Olive Green, Lime Peel. Sharpen edges with Olive Green (Verithin).

ANOTHER
foxglove *By Judy McDonald*

COLOR PALETTE

Mulberry

Jasmine

Dark Purple

Hot Pink

Process Red

White

Cream

Deco Yellow

Magenta

Blush Pink

Dahlia Purple

Grass Green

Dark Green

Olive Green

True Green

Light Green

Spring Green

1. Layer Mulberry, Jasmine, leaving lightest values free of color.

2. Layer spots with Dark Purple.

3. Layer Hot Pink, Process Red, leaving highlights free of color. Burnish with White, Cream.

4. Lightly burnish top of flower with Deco Yellow. Lightly burnish with Hot Pink, Process Red, Magenta.

5. Lightly burnish edges with Blush Pink, Dahlia Purple.

6. Burnish spots with Dahlia Purple.

7. Layer Grass Green on leaves and stems, leaving lightest values free of color.

8. Layer darker values with Dark Green, Olive Green. Layer middle values with True Green, Light Green, Spring Green.

9. Burnish with White, Cream.

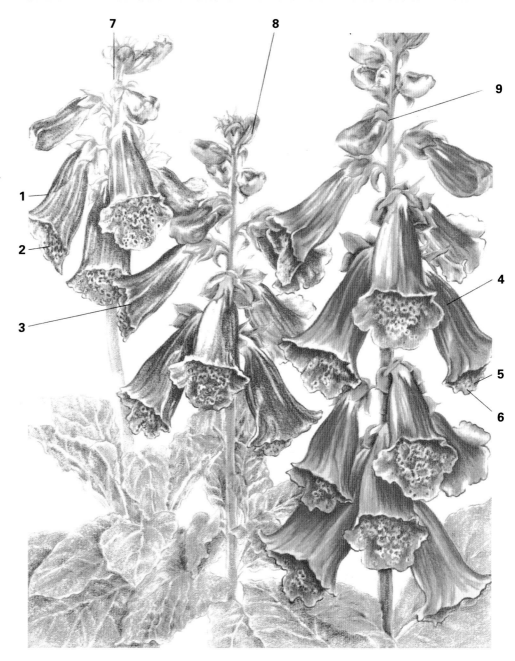

fuchsia

COLOR PALETTE

Cool Grey 70%

Crimson Red

Scarlet Lake

Magenta

Carmine Red

White

Crimson Red (Verithin)

Black Grape

Imperial Violet

Purple Violet (Polychromos)

Lilac

Lavender

Mulberry

Parma Violet (Verithin)

Warm Grey 20% (Verithin)

Process Red (Verithin)

French Grey 20%

French Grey 70%

Terra Cotta

Warm Grey 90%

Permanent Green Olive (Polychromos)

Olive Green

May Green (Polychromos)

Olive Green (Verithin)

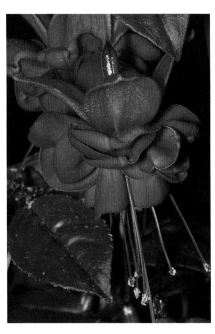

Reference Photo

RED PETALS

1. Layer shadows with Cool Grey 70%, Crimson Red. Layer Scarlet Lake, Magenta, Carmine Red.

2. Burnish with White, except shadow areas.

3. Burnish with Scarlet Lake (dark values), Carmine Red, White (light values). Repeat as required. Sharpen edges with Crimson Red (Verithin).

LAVENDER PETALS

4. Layer shadows with Cool Grey 70%, Black Grape. Layer dark values with Imperial Violet. Layer Purple Violet (Polychromos), Lilac, Lavender, Carmine Red.

5. Burnish with White, except shadow areas.

6. Lightly layer Mulberry on random petals. Burnish with Purple Violet (Polychromos), Lilac, Lavender. Burnish light values with White. Repeat as required. Sharpen edges with Parma Violet (Verithin).

PISTIL AND STAMEN

7. Using sharp Verithins, layer Warm Grey 20% (shadows), Crimson Red, Process Red. Burnish with White. Burnish with Process Red (Verithin). Burnish the left side of the pistil with White.

8. Layer ends of pistils with French Grey 20%, 70%. Randomly burnish with White.

STEM AND LEAVES

9. Layer stem with Terra Cotta. Burnish with French Grey 20%. Burnish with Terra Cotta.

10. Layer dark values with Warm Grey 90%. Layer pod with Green Olive (Polychromos), Olive Green. Leave highlights free of color.

11. Draw leaf veins with Terra Cotta. Layer dark values with Warm Grey 90%. Layer Permanent Green Olive (Polychromos), Olive Green.

12. Burnish with White, May Green (Polychromos), Olive Green. Repeat as required. Sharpen edges with Olive Green (Verithin).

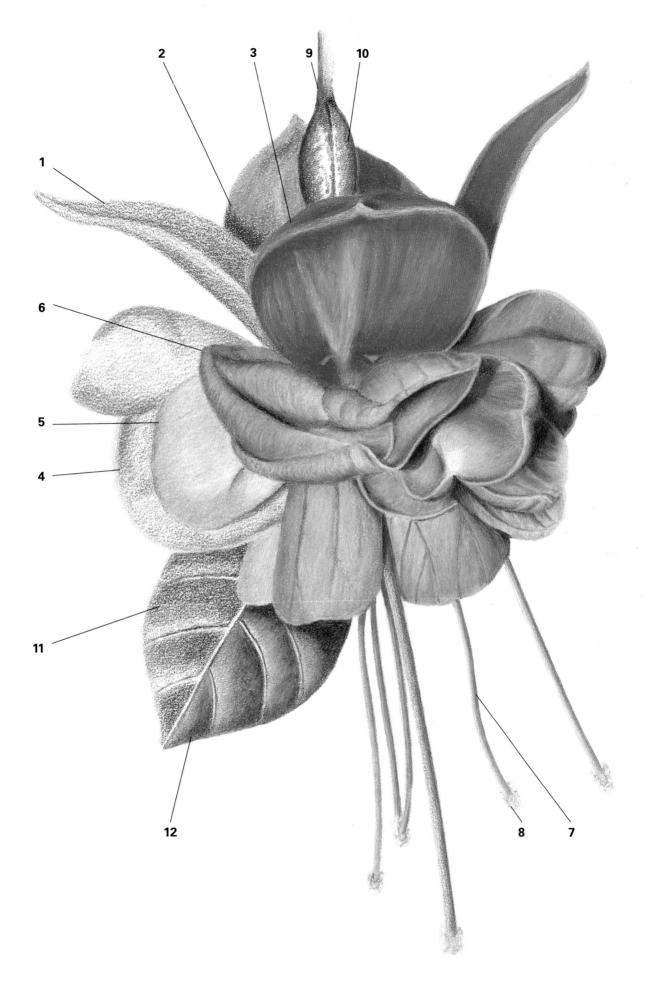

geranium *By Edna Henry*

COLOR PALETTE

(All colors are Polychromos unless otherwise noted.)

Pink Madder Lake

Light Purple Pink

Red-Violet

Magenta

Pink Carmine

Permanent Carmine

Light Cadmium Red

May Green

Burnt Carmine

Dark Purple (Prismacolor)

Bluish Turquoise

Pine Green

Hooker's Green

Copenhagen Blue (Prismacolor)

FLOWER

1. Layer Pink Madder Lake.

2. Layer Light Purple Pink. Layer shadows with Red-Violet, Magenta.

3. Layer Pink Carmine, Permanent Carmine.

4. Layer center with tiny strokes of Permanent Carmine, Light Cadmium Red, May Green.

5. Layer shadows with Burnt Carmine, Dark Purple (Prismacolor), Light Cadmium Red.

LEAVES

6. Layer May Green.

7. Layer Bluish Turquoise.

8. Layer Pine Green.

9. Layer Hooker's Green. Layer shadows with Copenhagen Blue (Prismacolor), Burnt Carmine, Dark Purple (Prismacolor). Lightly layer Permanent Carmine on leaf surface.

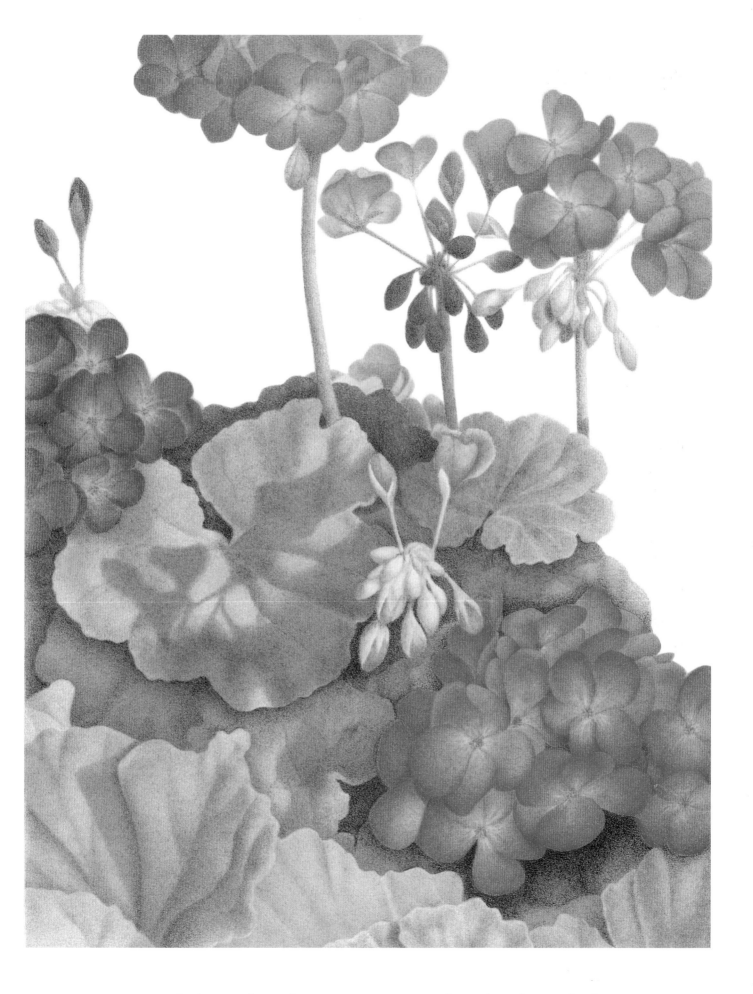

gerbera daisy

COLOR PALETTE

Cream (Polychromos)

Yellow Ochre

Goldenrod

French Grey 10%

French Grey 30%

French Grey 50%

French Grey 90%

Spanish Orange

Sunburst Yellow

Pumpkin Orange

Yellowed Orange

White (Verithin)

Spanish Orange (Verithin)

Deep Cobalt Green
(Polychromos)

Olive Green

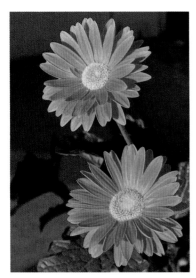

Reference Photo

1

2

3

4

CENTER

1. Layer Cream (Polychromos). Wash with Bestine and a cotton swab.

2. Layer Yellow Ochre, except in center. Wash with Bestine and a cotton swab.

3. Burnish with Goldenrod. Dab with Bestine and a cotton swab.

4. Develop highlight areas by erasing randomly with a sharpened imbibed eraser strip in an electric eraser. Layer center with Yellow Ochre. Lightly burnish shadows with French Grey 30%.

PETALS

5. Layer shadows with French Grey 50%. Wash with Bestine and a cotton swab.

6. Layer Spanish Orange, Sunburst Yellow, leaving edges free of color. Wash with Bestine and a cotton swab.

7. Burnish shadows with Pumpkin Orange.

8. Layer Pumpkin Orange, Yellowed Orange. Wash with Bestine and a no. 6 brush.

9. Burnish with Sunburst Yellow.

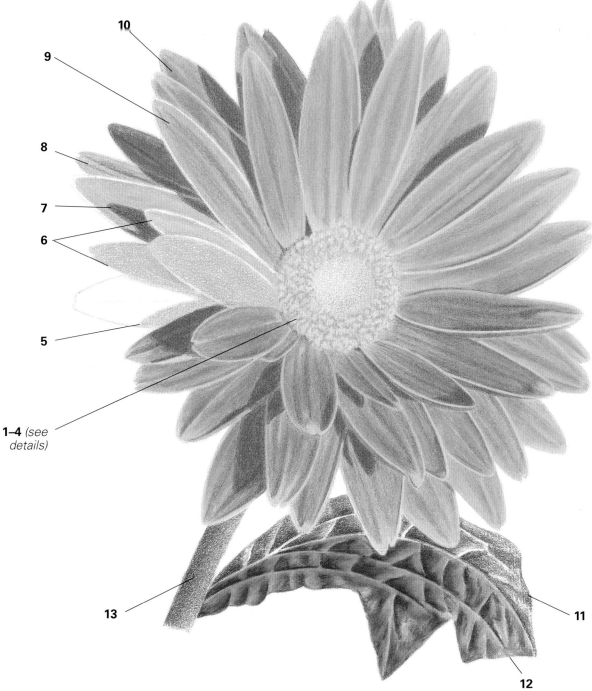

10. Lightly layer edges with Sunburst Yellow. Burnish with White (Verithin). Sharpen edges with Spanish Orange (Verithin).

LEAF

11. Layer French Grey 90%, Deep Cobalt Green (Polychromos), Olive Green.

12. Burnish with French Grey 10%. Then burnish with Deep Cobalt Green (Polychromos), French Grey 30%.

STEM

13. Layer French Grey 90%, Deep Cobalt Green (Polychromos), Olive Green.

gladiolus

COLOR PALETTE

French Grey 10%

French Grey 20%

French Grey 30%

French Grey 50%

Cream (Polychromos)

Cream

Pale Yellow (Pablo)

Goldenrod

Yellow Ochre

Naples Yellow
(Polychromos)

Cinnamon
(Polychromos)

Dark Flesh (Polychromos)

Salmon Pink

Apricot (Luminance)

White

Apple Green

Henna

Tuscan Red (Verithin)

Cool Grey 10%

Cool Grey 30%

Cool Grey 70%

Olive Green

Olive Green (Verithin)

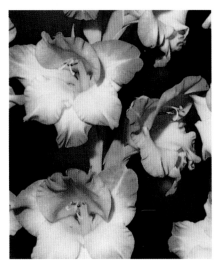

Reference Photo

PETALS

1. Layer shadows, dark values and light yellow areas with French Grey 30%, 20%, 10%. Wash with Bestine and a no. 6 brush.

2. Layer Cream (Polychromos), Cream, Pale Yellow (Pablo). Wash with Bestine and a no. 6 brush.

3. Layer Goldenrod, Yellow Ochre, Naples Yellow (Polychromos). Wash with Bestine and a no. 6 brush.

4. Layer shadows, dark values and salmon areas with French Grey 50%, Cinnamon (Polychromos).

5. Layer Dark Flesh (Polychromos), Salmon Pink, Apricot (Luminance). Wash with Bestine and a no. 6 brush.

6. Burnish light yellow areas with Cream and White (light values only). Overlap into salmon area.

7. Burnish salmon areas with Dark Flesh (Polychromos), Salmon Pink, Apricot (Luminance)

PISTILS AND CENTER

8. Layer French Grey 30%, 10%. Wash with Bestine and a no. 4 brush. Layer Cream. Wash with Bestine and a no. 4 brush.

9. Lightly layer Apple Green. Wash with Bestine and a no. 4 brush.

10. Lightly burnish darker values with French Grey 20% to define pistils. Layer Henna to accent areas of inner petals. Wash with Bestine and a no. 4 brush. Burnish with Tuscan Red (Verithin).

STEM AND BUDS

11. Layer dark values with Cool Grey 70%. Layer Cool Grey 30%, Olive Green, Apple Green.

12. Burnish with Cool Grey 10%. Wash with Bestine and a cotton swab. Burnish dark values with Olive Green. Burnish Apple Green, Cool Grey 10%. Repeat washing and burnishing as necessary. Sharpen edges with Olive Green (Verithin).

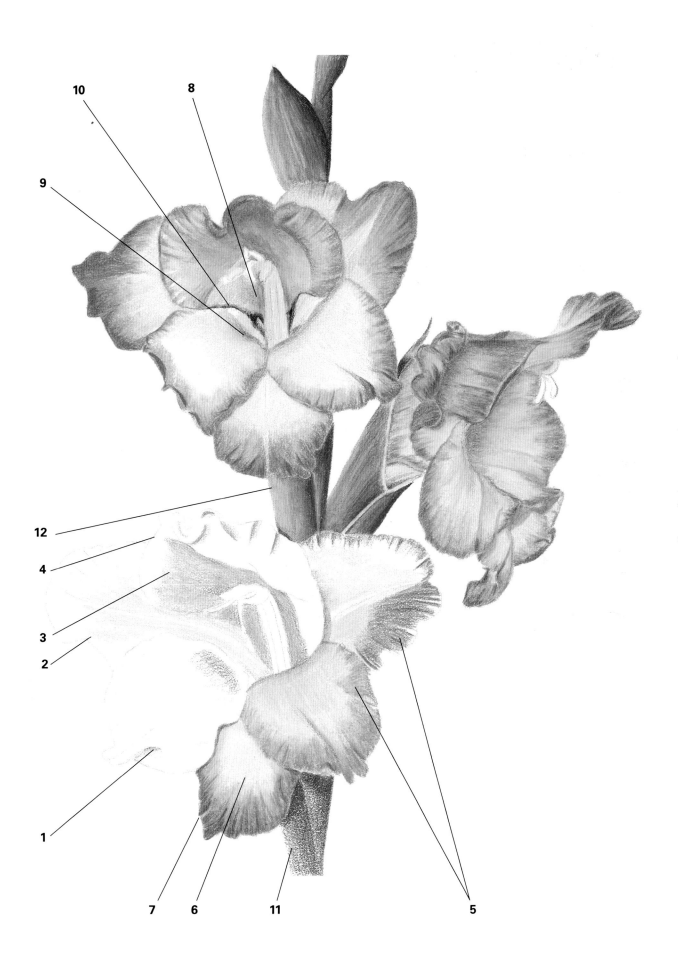

hibiscus

COLOR PALETTE

Orange (Verithin)
Jasmine
Apricot (Luminance)
Blush Pink
White
French Grey 10%
French Grey 20%
White (Verithin)
Goldenrod

Cream (Polychromos)
Cream
Spanish Orange
Pale Vermilion
Warm Grey 70%
Warm Grey 90%
Tuscan Red
Crimson Red
Cool Grey 70% (Verithin)

Deep Cobalt Green (Polychromos)
Pine Green (Polychromos)
Earth Green Yellowish (Polychromos)
Apple Green

PETALS

1. Lightly define veins with Orange (Verithin). Layer with Jasmine, leaving highlight area adjacent to veins free of color. Layer with Apricot (Luminance) and Blush Pink.

2. Burnish with White.

3. Lightly burnish shadows with French Grey 20%. Wash with Bestine and a cotton swab. Burnish with Blush Pink, Apricot (Luminance), Jasmine. Lightly layer vein highlights with Jasmine. Burnish with White (Verithin).

PISTIL AND STAMEN

4. Layer left edge with French Grey 10%, Goldenrod, Cream (Polychromos). Burnish with Cream.

5. Burnish left edge with Spanish Orange, Goldenrod.

6. Layer with Pale Vermilion, Apricot (Luminance). Burnish with Cream. Burnish edge with Pale Vermilion.

7. Burnish with Cream (Polychromos), Goldenrod.

CENTER

8. Layer with Warm Grey 90%, Tuscan Red, Crimson Red.

9. Lightly burnish lighter values with Blush Pink. Burnish with Crimson Red.

LEAVES

10. Draw veins with Cool Grey 70% (Verithin). Layer Warm Grey 70%, Deep Cobalt Green (Polychromos), Pine Green (Polychromos), Earth Green Yellowish (Polychromos), leaving highlights free of color.

11. Burnish with Apple Green.

12. Burnish with Pine Green (Polychromos), Earth Green Yellowish (Polychromos). Layer vein highlights with Apple Green. Burnish with White (Verithin).

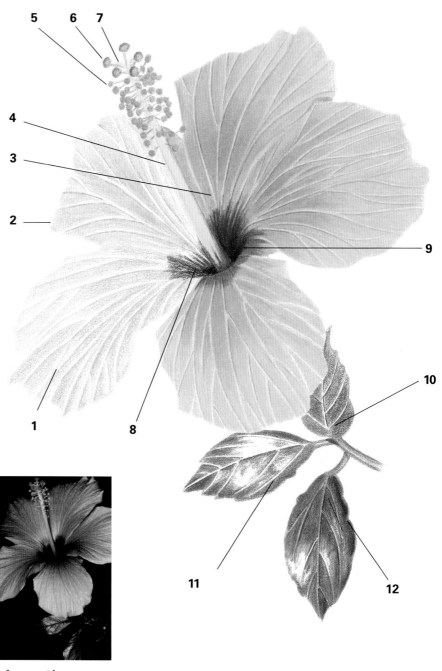

Reference Photo

hollyhock

COLOR PALETTE

Pale Yellow (Pablo)
Chartreuse
Tuscan Red
Crimson Red
Crimson Red (Verithin)
White (Verithin)
Process Red

Pink Carmine
(Polychromos)
White
Green Ochre (Pablo)
Lime Peel
Cream

Deep Cobalt Green
(Polychromos)
Olive Green
Apple Green
Cool Grey 10%
True Green (Verithin)

1. Layer centers with Pale Yellow (Pablo). Wash with Bestine and cotton swab. Layer Chartreuse, leaving center and outer edge Pale Yellow (Pablo). Wash with Bestine and cotton swab.

2. Layer shadows with Tuscan Red. Draw veins with Crimson Red. Draw Crimson Red (Verithin) lines over Crimson Red. Impress lines with White (Verithin) next to red veins.

3. Layer Process Red, Pink Carmine (Polychromos).

4. Burnish with White, except darkest values, impressed lines and area overlapping yellow center.

5. Lightly burnish Process Red, Pink Carmine (Polychromos).

6. Burnish with White (Verithin).

7. To complete the centers, layer Green Ochre (Pablo), Lime Peel. Wash with Bestine and a no. 4 brush. Lightly burnish light values with Cream or White (Verithin).

8. Erase with sharpened eraser strip in. Dab with Bestine and a no. 4 brush.

9. Lightly burnish with Pale Yellow (Pablo), dragging red into center area.

10. Draw veins with Deep Cobalt Green (Polychromos). Impress lines with White (Verithin) next to veins. Layer Olive Green, Apple Green. Lightly burnish with Cream, Cool Grey 10%. Lightly burnish with Olive Green, Apple Green. Wash with Bestine and no. 4 brush. Using light strokes, layer hair with True Green (Verithin).

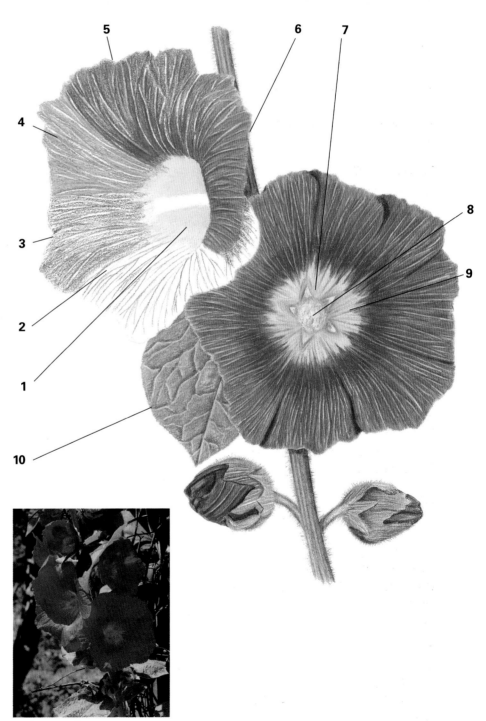

Reference Photo

hydrangea

COLOR PALETTE

French Grey 30%
French Grey 50%
French Grey 70%
French Grey 90%
Naples Yellow
(Polychromos)
Jasmine
Deco Yellow
Cream

Violet
Parma Violet
Violet (Polychromos)
Lilac
Greyed Lavender
Lavender
Pink
Deco Pink
White

Parma Violet (Verithin)
White (Verithin)
Olive Black (Pablo)
Olive Green
Chrome Oxide Green
(Polychromos)
Green Ochre (Pablo)
Olive Green (Verithin)

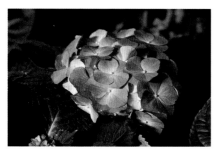

Reference Photo: petals

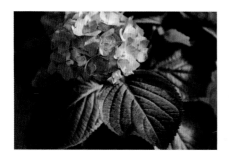

Reference Photo: leaves

PETALS

1. Layer shadows with French Grey 70%. Wash with Bestine and a no. 4 brush.

2. Layer Naples Yellow (Polychromos), Jasmine, Deco Yellow, Cream. Wash with Bestine and a no. 4 brush. Lightly burnish with French Grey 50%, 30%. Wash with Bestine and a no. 4 brush.

3. a: Layer dark values with French Grey 70%, Violet. Layer with Parma Violet, Violet (Polychromos), Lilac, Greyed Lavender, Lavender, Pink, Deco Pink. **b:** Wash with Bestine and a no. 4 brush. **c:** Lightly burnish with White, except darkest values.

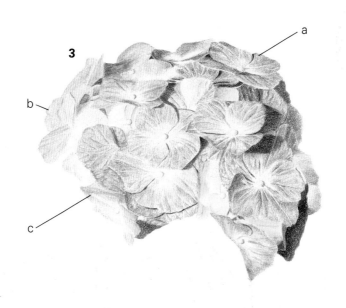

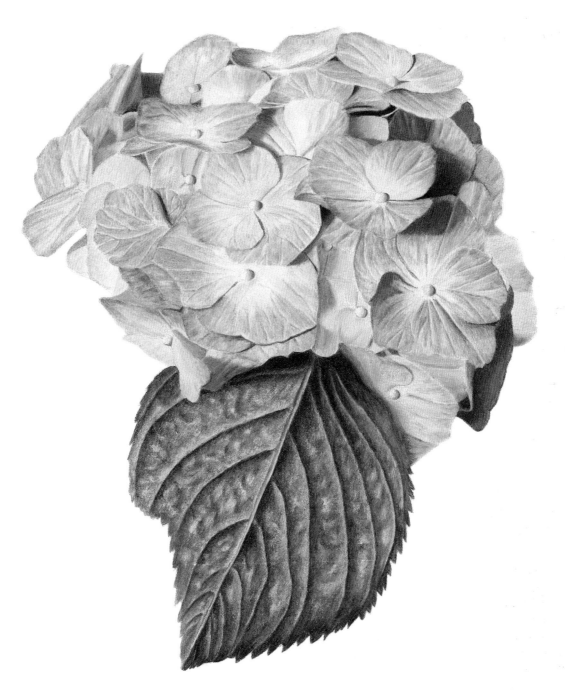

4. To finish the petal, lightly burnish with Violet (Polychromos), Greyed Lavender, Lavender, Deco Pink. Repeat burnishing with White and the colors in this step as necessary. Sharpen edges of dark petals with Parma Violet (Verithin) and edges of light petals with White (Verithin).

LEAF

5. Layer dark values with French Grey 90%. Layer Olive Black (Pablo), Olive Green, Chrome Oxide Green (Polychromos), Green Ochre (Pablo). Lightly burnish light values with Cream. Burnish with Green Ochre (Pablo). Burnish with Olive Black (Pablo), Olive Green, Chrome Oxide Green (Polychromos). Repeat burnishing with Green Ochre (Pablo), Olive Black (Pablo), Olive Green, Chrome Oxide Green (Polychromos) as necessary. Sharpen edges with Olive Green (Verithin).

hyacinth *By Susan L. Brooks*

COLOR PALETTE

Blue Slate
Light Blue (Derwent WS)
Indigo Blue
Violet Blue

Smalt Blue
 (Derwent WS)
Blue Violet Lake
 (Derwent WS)

Specturm Blue
 (Derwent WS)
True Blue
Lilac

Cloud Blue
White
Mulberry
Indigo Blue (Verithin)

1. Layer edges with Blue Slate. Burnish with colorless blender.

2. Layer outside with Light Blue (Derwent WS). Burnish with colorless blender.

3. Layer inside and shadows with Indigo Blue, Violet Blue. Burnish with colorless blender. Repeat steps 1-3.

4. Lightly layer Smalt Blue (Derwent WS), Blue Violet Lake (Derwent WS), Spectrum Blue (Derwent WS), True Blue, Lilac.

5. Layer highlights with Blue Slate, Cloud Blue, White. Lightly burnish rims with Blue Slate.

6. Layer lavender areas with Mulberry.

7. Lightly burnish shadows with Indigo Blue, Violet Blue.

8. Burnish with True Blue.

9. Lightly burnish rims with Blue Slate, Cloud Blue, White. Sharpen edges with Indigo Blue (Verithin).

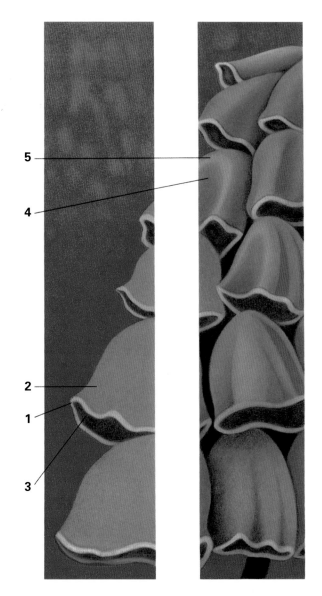

iris

Reference Photo

1. Lightly Layer Cool Grey 20%, Cream, Cadmium Yellow (Polychromos). Wash with Bestine and a cotton swab. Layer Cool Grey 20%. Wash with Bestine and a cotton swab.

2. Impress short strokes to center with Spanish Orange (Verithin), using heavy pressure. Fill in with Dahlia Purple (Verithin).

3. Lightly layer dark values with Black Grape using short, stippling strokes that start at the outer edge of the petal and follow its contour. Layer Violet Blue, Violet, Dahlia Purple.

4. Dab purple areas with Bestine and a small brush. Randomly burnish with White.

5. Burnish with Violet and Dahlia Purple using same strokes as in step 3. Burnish center with Sunburst Yellow.

6. Drag color into white areas with a dry cotton swab.

7. Lightly stipple spotted variegations with Dahlia Purple.

8. Draw veins and sharpen edges with Violet (Verithin).

9. Layer bud with Lime Peel, Apple Green, French Grey 20%, Cadmium Yellow (Polychromos). Wash with Bestine and a cotton swab. Burnish light values with White and dark values with French Grey 10%. Lightly burnish Lime Peel, Apple Green, Cadmium Yellow (Polychromos).

10. Burnish top of bud with Black Grape and Violet Blue.

11. Layer bottom of bud with Light Umber. Burnish with Sepia, Dark Umber, Light Umber, French Grey 10%.

12. Layer dark values of stems with Olive Green. Layer True Green, Apple Green, Lime Peel. Burnish with French Grey 20%. Burnish dark values with Olive Green. Burnish with Apple Green, Lime Peel.

13. Layer Terra Cotta, Light Umber, Hazel (Pablo), Sepia. Lightly burnish Jasmine,

COLOR PALETTE

Cool Grey 20%	Dahlia Purple	Dark Umber
Cream	White	Olive Green
Cadmium Yellow (Polychromos)	Sunburst Yellow	True Green
Spanish Orange (Verithin)	Violet (Verithin)	Terra Cotta
Dahlia Purple (Verithin)	Lime Peel	Hazel (Pablo)
Black Grape	Apple Green	Jasmine
Violet Blue	French Grey 10%	Olive Green (Verithin)
Violet	French Grey 20%	True Green (Verithin)
	Light Umber	
	Sepia	

Cream, French Grey 20%, Hazel (Pablo). Draw veins with Light Umber.

14. Layer leaves with Olive Green (dark values only), Lime Peel, Apple Green, True Green.

15. Burnish dark values with Lime Peel and light values with Cream. Sharpen dark edges with Olive Green (Verithin) and light edges with True Green (Verithin).

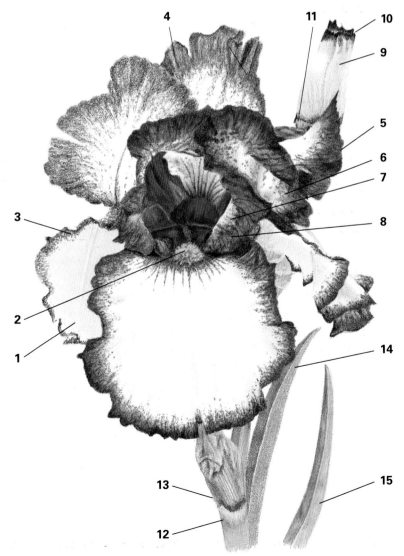

lily *By Kristy Kutch*

PETALS

1. Lightly layer Pink Rose, Pink, Raspberry, Tuscan Red.

2. Layer variegations with Tuscan Red, Raspberry. Layer around variegations with Pink.

3. Impress veins with 7H graphite pencil and drafting or tracing paper. Do not impress lines over variegations. Lightly layer next to impressed line with Greyed Lavender, Black Grape. Layer shadows with Greyed Lavender, using linear strokes.

4. Lightly layer green area with Yellow Chartreuse, Lime Peel, Olive Green. Lightly layer shadows with Tuscan Red.

5. Burnish with White, except green area. Burnish with Pink Rose, Pink.

6. Drag pigment from variegations into surrounding area with fine-point colorless blender. Lightly layer outer area with Process Red. Burnish inside variegations with Indigo Blue (Verithin).

7. Sharpen edges with Indigo Blue (Verithin) or Tuscan Red (Verithin).

PISTILS AND STAMEN

8. Layer shadows with Greyed Lavender. Layer Tuscan Red (Verithin), Olive Green, Yellow Chartreuse, Lime Peel. Burnish with White. Burnish with Olive Green, Yellow Chartreuse, Lime Peel. Burnish shadows with Black Grape, Indigo Blue (Verithin).

COLOR PALETTE

Pink Rose

Pink

Raspberry

Tuscan Red

Greyed Lavender

Black Grape

Yellow Chartreuse

Lime Peel

Olive Green

White

Process Red

Indigo Blue (Verithin)

Tuscan Red (Verithin)

Dark Green

Cream

LEAVES

9. Layer Yellow Chartreuse. Impress veins with 7H graphite pencil and drafting or tracing paper. Layer Lime Peel, Olive Green, Dark Green. Burnish with Cream. Randomly lift off areas with a small piece of kneaded eraser by stamping surface. Lightly burnish shadows with Black Grape, Indigo Blue (Verithin). Sharpen edges with Indigo Blue (Verithin) or Tuscan Red (Verithin).

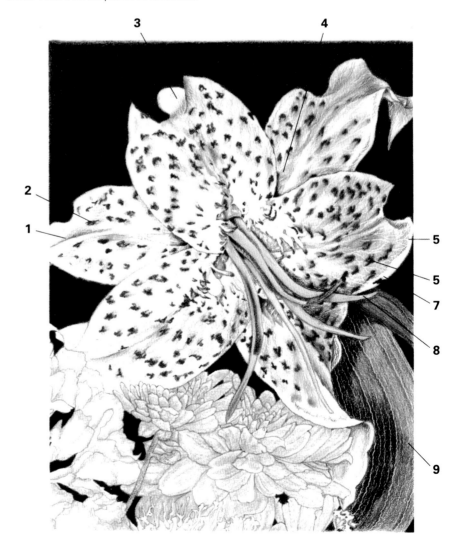

lupine By Judy McDonald

COLOR PALETTE

Indigo Blue	Spring Green	Lilac	Peacock Green
Violet	Violet Blue	True Blue	Parrot Green
Tuscan Red	Hot Pink	Dark Purple	Light Aqua
Olive Green	Lavender	Dark Green	

1. Layer flowers with Indigo Blue, leaving highlights free of color.

2. Layer shadows with Violet.

3. Layer upper stem with Tuscan Red, lower stem with Olive Green, Spring Green.

4. Layer shadows with Violet Blue. Layer petals with Hot Pink, Lavender, Lilac, True Blue.

5. Layer shadow areas of stem and edge of petals with Dark Purple.

6. Layer shadows in leaves with Tuscan Red, Dark Purple.

7. Layer dark values with Dark Green, leaving highlights free of color.

8. Layer middle values with True Blue, Peacock Green, Parrot Green. Layer light values with Light Aqua, Spring Green.

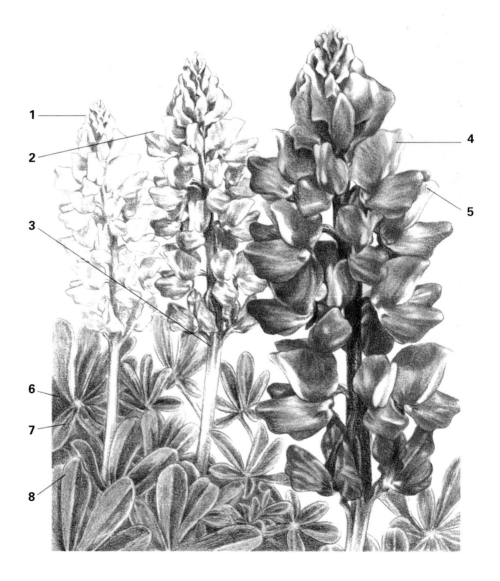

magnolia

COLOR PALETTE

Tuscan Red	Pink Rose	Deco Peach	Brownish Beige (Supracolor)
Henna	Magenta	Deco Pink	Burnt Umber (Derwent WS)
Cinnamon (Polychromos)	Process Red	White	Dark Umber
Clay Rose	Hot Pink	Olive Green	
Rosy Beige	Pink	Lime Peel	

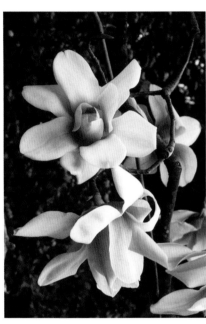

Reference Photo

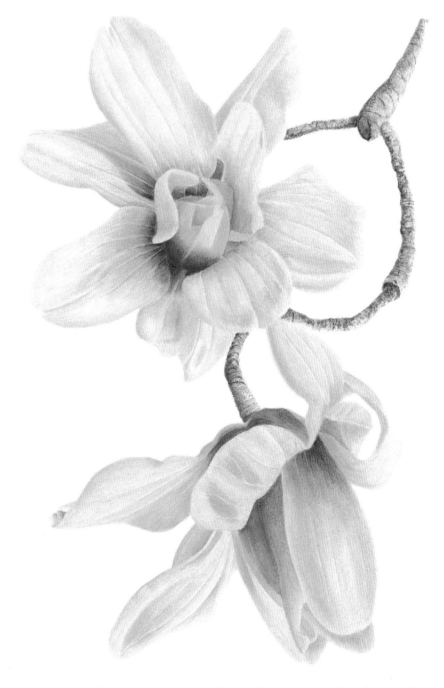

FLOWER

1. Layer shadows with Tuscan Red, Henna, Cinnamon (Polychromos). Wash with Bestine and a no. 6 brush.

2. Layer dark values with Clay Rose, Rosy Beige, Pink Rose. Wash with Bestine and a no. 6 brush.

3. Layer Magenta, Process Red, Hot Pink, Pink. Wash with Bestine and a no. 6 brush.

4. Layer Deco Peach, Deco Pink. Wash with Bestine and a cotton swab. To finish the flower, burnish shadows with Henna. Then lightly burnish dark values with Pink Rose. Wash with Bestine and a no. 6 brush. Lightly burnish magenta areas with Hot Pink. Wash with Bestine and a no. 6 brush. Keep repeating this sequence as necessary. Lightly burnish lighter areas with White. Wash with Bestine and a no. 6 brush. Burnish with Deco Pink.

BRANCHES

5. Layer Olive Green, Lime Peel. Wash with Bestine and a cotton swab.

6. Lightly layer Brownish Beige (Supracolor). Dab with water and a no. 6 brush.

7. Lightly layer Burnt Umber (Derwent WS). Dab with water and a no. 6 brush.

8. Layer dark values with Dark Umber.

9. Lightly burnish green area with Olive Green, Lime Peel.

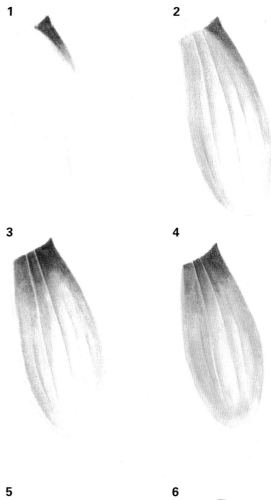

marigold

COLOR PALETTE

Goldenrod

Spanish Orange

Sunburst Yellow

Tuscan Red

Crimson Lake

Scarlet Lake

Poppy Red

Spanish Orange
(Verithin)

Olive Black (Pablo)

Olive Green

Grass Green

Lime Peel

Cream

Olive Green (Verithin)

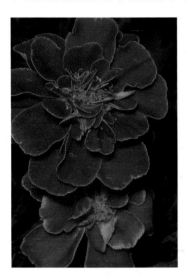

Reference Photo

PETALS

1. Layer dark values with Goldenrod. Wash with Bestine and a no. 6 brush.

2. Layer each petal individually with Goldenrod, Spanish Orange, Sunburst Yellow. Wash with Bestine and a cotton swab.

3. Layer dark values with Tuscan Red. Layer Crimson Lake, Scarlet Lake, Poppy Red.

4. Wash with Bestine and a cotton swab.

5. Burnish red areas with Scarlet Lake, Poppy Red. Burnish edges with Goldenrod, Spanish Orange. Sharpen edges with Spanish Orange (Verithin).

LEAVES AND STEM

6. Layer dark values with Olive Black (Pablo). Layer Olive Green, Grass Green, Lime Peel.

7. Burnish with Cream.

8. Burnish with Olive Green, Grass Green, Lime Peel. Sharpen edges with Olive Green (Verithin).

morning glory

COLOR PALETTE

Cool Grey 10%	Mulberry	Process Red (Verithin)	Apple Green
Cool Grey 20%	Process Red	Goldenrod (Verithin)	Peacock Green (Verithin)
Tuscan Red	Scarlet Lake	Dark Green	True Green (Verithin)
Dahlia Purple	White	True Green	

PETALS

1. Layer center with Cool Grey 20%, 10%. Leave paper free of color for pistils. Wash with Bestine and a no. 4 brush.

2. Layer Tuscan Red, Dahlia Purple, Mulberry, Process Red, using linear strokes.

3. Wash with Bestine and a cotton swab following strokes described in step 2.

4. Layer star area with Process Red, Scarlet Lake. Wash with Bestine and a cotton swab.

5. Burnish with White, except dark values.

6. Lightly burnish with Dahlia Purple, Mulberry. Burnish with Process Red. Blend into center area with White. Sharpen edges with Process Red (Verithin).

LEAVES

7. Draw veins with Goldenrod (Verithin). Randomly layer Dark Green, True Green, Apple Green.

8. Dab with Bestine and a cotton swab.

9. Burnish with White.

10. Lightly burnish with Dark Green, True Green, Apple Green. Sharpen edges with Peacock Green (Verithin) and True Green (Verithin).

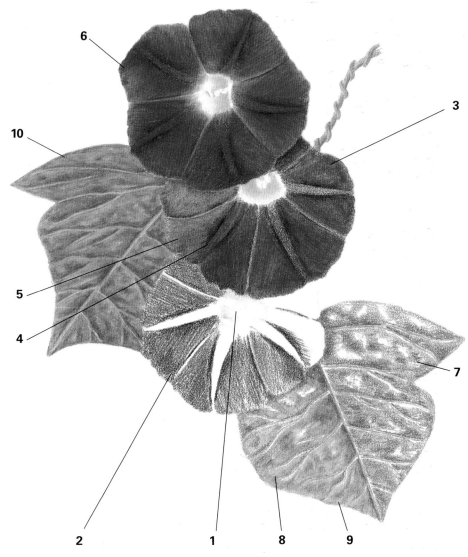

nasturtium

COLOR PALETTE

Raw Sienna (Derwent WS)

Deep Cadmium (Derwent WS)

Spectrum Orange (Derwent WS)

Tuscan Red

Crimson Lake

Crimson Red

Poppy Red

Pale Vermilion

Tuscan Red (Verithin)

Crimson Red (Verithin)

Pale Vermilion (Verithin)

Spanish Orange (Verithin)

Light Umber

Goldenrod

Canary Yellow

Canary Yellow (Verithin)

Straw Yellow (Derwent WS)

Olive Yellow (Pablo)

Olive Black (Pablo)

1. Layer center with Raw Sienna (Derwent WS). Wash with water and a no. 8 brush, wiping off excess water.

2. Layer Deep Cadmium (Derwent WS). Wipe off excess water before applying and wash with water and a no. 8 brush.

3. Layer Spectrum Orange (Derwent WS). Wipe off excess water before applying and wash with water and a no. 8 brush.

4. With a small amount of water, lightly wash step 3 with a cotton swab.

5. Gently erase light values with a kneaded eraser.

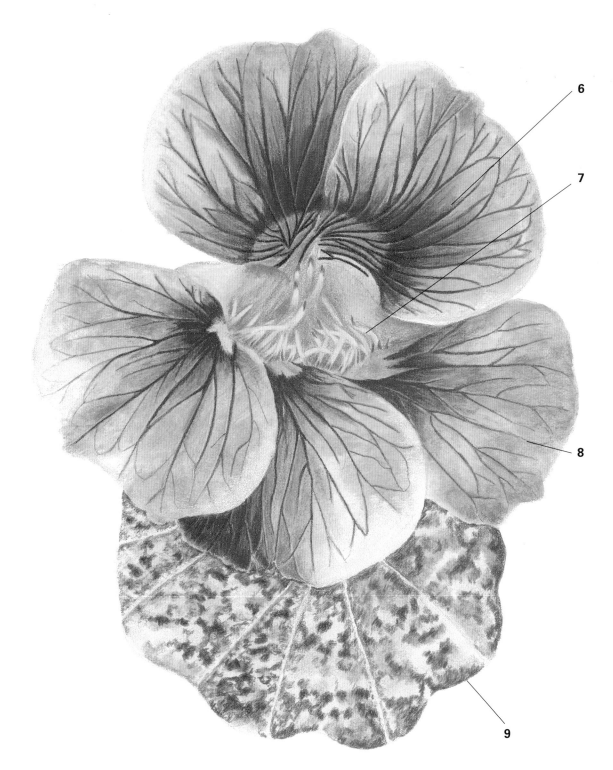

6. Layer variegations with Tuscan Red, Crimson Lake, Crimson Red, Poppy Red, Pale Vermilion. Lightly wash with Bestine and no. 4 brush. Burnish with Tuscan Red (Verithin), Crimson Red (Verithin), Pale Vermilion (Verithin), Spanish Orange (Verithin).

7. Erase center area with sharpened eraser strip. Burnish surrounding area with Light Umber, Goldenrod, creating stamen shapes. Lightly wash with Bestine and a small brush. Burnish stamen with Canary Yellow, Crimson Red.

8. Sharpen edges and variegations with Crimson Red, Pale Vermilion (Verithin), Spanish Orange (Verithin) or Canary Yellow (Verithin).

9. Layer leaf with Straw Yellow (Derwent WS). Wash with water and no. 6 brush. Randomly layer with Olive Yellow (Pablo). Wash with Bestine and no. 6 brush. Randomly layer and burnish with Olive Black (Pablo). Dab with Bestine and a cotton swab, dabbing color into lighter areas. Repeat layering and burnishing with Olive Black (Pablo), dabbing with Bestine as necessary.

orchid: lady's slipper

COLOR PALETTE

French Grey 10%	Cream	Light Umber	Olive Green (Verithin)
French Grey 20%	Apple Green	Olive Green	Cadmium Yellow (Polychromos)
French Grey 30%	Olive Yellow (Pablo)	Tuscan Red (Verithin)	Warm Grey 90%
French Grey 50%	Raspberry	Mulberry	Lime Peel
	Henna	Magenta	

Reference Photo

PETALS

1. Layer top edge of vertical petal with French Grey 50% and 20%. Wash with Bestine and a cotton swab. Burnish with French Grey 10%.

2. Layer bottom of vertical petal and the horizontal petals with Cream. Wash with Bestine and a cotton swab.

3. Layer upper portion of horizontal petals with Apple Green, Olive Yellow (Pablo). Wash with Bestine and a cotton Swab.

4. Layer horizontal petals with Raspberry, Henna, Light Umber. Wash with Bestine and a cotton swab.

5. Layer Raspberry, Henna, Light Umber. Lightly burnish with Cream.

6. Draw variegations on horizontal petals with Apple Green and Raspberry.

7. Draw green variegations on lower part of vertical petal with Olive Green and Apple Green. Lightly layer between variegations with Apple Green. Wash with Bestine and a no. 6 brush. Lightly burnish with Cream.

8. Draw dark red variegations with Tuscan Red (Verithin). Layer between variegations with Mulberry and Magenta. Then drag into green area with a dry cotton swab. Lightly wash with Bestine and no. 6 brush. Burnish red and green variegations of vertical petal with Tuscan Red (Verithin) and Olive Green (Verithin).

9. Burnish dark red area at top of horizontal petals with Tuscan Red (Verithin). Add hairs with sharp Tuscan Red (Verithin). Sharpen hairs with Tuscan Red (Verithin).

CENTER

10. Layer with Cadmium Yellow (Polychromos), Cream. Wash with Bestine and a cotton swab. Layer shadows with French Grey 30%, 20%. Lightly layer Henna; smudge with a dry cotton swab. Wash with Bestine and a no. 4 brush.

11. Add details with Tuscan Red (Verithin), Warm Grey 90%, Olive Green.

LOWER PETAL

12. Layer dark values with Tuscan Red (Verithin). Layer Raspberry, Henna. Wash with Bestine and a cotton swab. Lightly erase with a kneaded eraser. Lightly burnish with Raspberry, Henna.

13. Draw veins and sharpen edges with Tuscan Red (Verithin).

STEM

14. Layer Olive Green, Lime Peel. Burnish with French Grey 10%. Burnish Olive Green, Lime Peel.

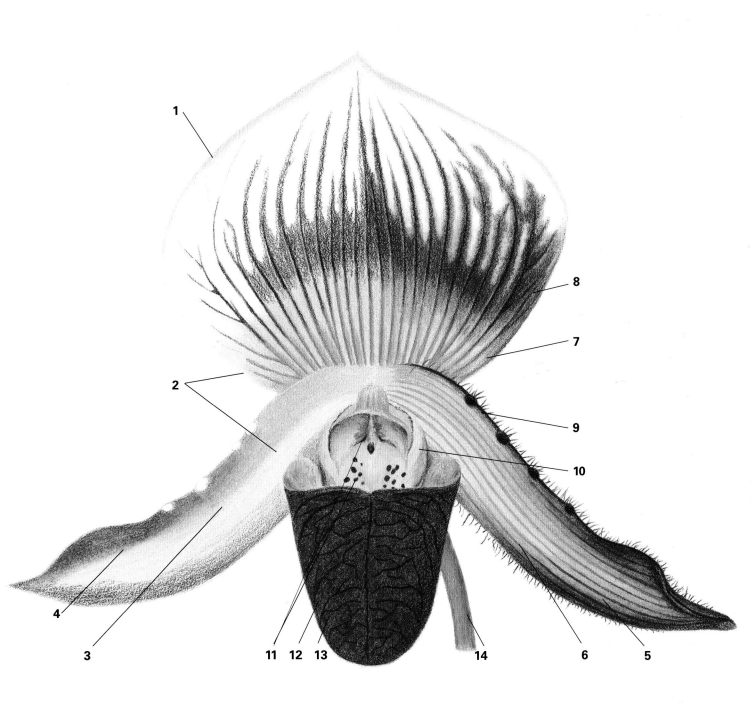

orchid: hybrid 1

COLOR PALETTE

Sunburst Yellow

Canary Yellow

Cream (Polychromos)

White

Crimson Red

Warm Grey 20% (Verithin)

Tuscan Red

Crimson Lake

Magenta

Process Red

Crimson Red (Verithin)

Magenta (Verithin)

French Grey 10%

French Grey 50%

Olive Green

May Green (Polychromos)

Olive Green (Verithin)

True Green (Verithin)

Reference Photo: flower

Reference Photo: leaf

CENTERS

1. Burnish radial patterns and darker yellow areas with Sunburst Yellow.

2. Layer Canary Yellow, Cream (Polychromos).

3. Lightly burnish with White. Burnish with Canary Yellow, Cream (Polychromos).

4. Layer ends of radial patterns with Crimson Red. Burnish center area with Crimson Red.

5. Lightly burnish center white area with Warm Grey 20% (Verithin).

PETALS

6. Layer shadows with Tuscan Red.

7. Lightly burnish veins with Crimson Lake, Crimson Red.

8. Layer with overlapping gradations of Crimson Red, Magenta, Process Red, leaving white areas free of color.

9. Burnish with White, except white areas, shadows and veins.

10. Burnish with overlapping gradations of Crimson Red, Magenta, Process Red, except white areas. Sharpen edges with Crimson Red (Verithin) or Magenta (Verithin), depending on corresponding color.

LEAF AND STEM

11. Layer shadows with French Grey 50%.

12. Layer Olive Green, using heavier application to right side of leaf; layer May Green (Polychromos).

13. Lightly burnish left side of leaf with Cream (Polychromos) and right side of leaf with French Grey 10%.

14. Lightly burnish left side of leaf with May Green (Polychromos) and right side of leaf with Olive Green. Repeat steps 13 and 14 as necessary. Sharpen dark edges with Olive Green (Verithin) and light edges with True Green (Verithin).

Download free bonus materials at **Artistsnetwork.com/Creating-Radiant-Flowers-In-Colored-Pencil**

orchid: hybrid 2

COLOR PALETTE

French Grey 10%	Goldenrod
French Grey 20%	Goldenrod (Verithin)
French Grey 50%	Tuscan Red
French Grey 70%	Henna
Terra Cotta	Tuscan Red (Verithin)
Pumpkin Orange	Permanent Green Olive (Polychromos)
Spanish Orange	May Green (Polychromos)
Sunburst Yellow	
Cream (Polychromos)	Cream
Mulberry	Olive Green
Magenta	Olive Green (Verithin)
Crimson Red	
White	

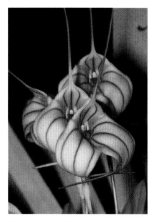

Reference Photo

PETALS

1. Layer light shadows with French Grey 20%, 10%. Wash with Bestine and a cotton swab.

2. Lightly layer dark shadows with French Grey 70% and Terra Cotta. Layer from center with overlapping gradations of Pumpkin Orange, Spanish Orange, Sunburst Yellow, Cream (Polychromos). Smudge with a dry cotton swab.

3. Lightly burnish with Pumpkin Orange, Spanish Orange, Sunburst Yellow, Cream (Polychromos).

4. Layer variegations from center with overlapping gradations of Mulberry, Magenta, Crimson Red. Smudge with a dry cotton swab.

5. On a separate sheet of paper, heavily burnish Magenta and Crimson Red. Pick up pigment with a dry cotton swab and apply to create light pink areas. Save cotton swab. Lightly burnish dark values with White or French Grey 10%.

6. Layer shadows in long petal extensions with French Grey 50%. Layer Goldenrod, Spanish Orange. Layer bottom extension with Magenta. Burnish with French Grey 20%, Goldenrod. Sharpen edges with Goldenrod (Verithin).

CENTER

7. Lightly layer white center area with French Grey 50%. With cotton swab used in step 5, apply pigment to this area. Lightly burnish variegations with Magenta, Crimson Red.

8. Layer dark values with Tuscan Red. Layer dark red center area with Henna. Burnish with French Grey 20%, Henna. Sharpen edge with Tuscan Red (Verithin).

LEAF AND STEM

9. Layer shadows with French Grey 70%. Layer Permanent Green Olive (Polychromos), May Green (Polychromos). Lightly burnish with Cream, Olive Green, May Green (Polychromos). Burnish light stem area with French Grey 10%. Sharpen edges with Green Olive (Verithin).

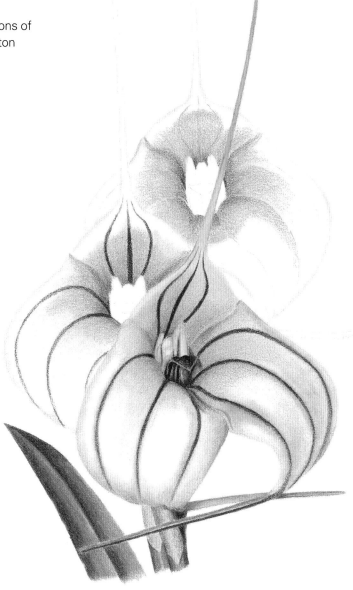

orchids: cymbidium

COLOR PALETTE

French Grey 10%	Apricot (Luminance)
French Grey 20%	Magenta
French Grey 30%	White
Olive Yellow (Pablo)	Process Red (Verithin)
Cadmium Yellow (Polychromos)	Deco Pink
Pale Yellow (Pablo)	Olive Green
Goldenrod	Apple Green
Hazel (Pablo)	Olive Green (Verithin)
Terra Cotta	True Green (Verithin)
Process Red	

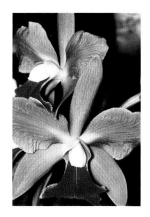

Reference Photo

YELLOW PETALS

1. Layer shadows with French Grey 30%. Wash with Bestine and a cotton swab.

2. Layer Olive Yellow (Pablo), Cadmium Yellow (Polychromos), Pale Yellow (Pablo). Wash with Bestine and a cotton swab.

3. Layer edge of petal with Goldenrod, allowing underpainting from step 2 to show through. Wash with Bestine and a cotton swab.

4. Layer Hazel (Pablo), using strokes that follow contours. Layer dark values with Terra Cotta.

5. Layer variegations with Process Red.

MAGENTA PETAL

6. Layer petal and inside center with Apricot (Luminance). Wash with Bestine and a cotton swab.

7. Layer petal values with Magenta. Layer Process Red.

8. Burnish with White.

9. Burnish dark values with Magenta, except edge of petal. Burnish with Process Red. Sharpen edge with Process Red (Verithin).

10. Burnish edge with White.

CENTER

11. Layer white center petals with Pale Yellow (Pablo), French Grey 20%, 10%. Burnish with White.

12. Lightly burnish variegations inside center with Process Red. Lightly burnish with Apricot (Luminance), White.

13. Draw variegations outside of left center petal with Deco Pink.

14. Layer French Grey 20% outside of right center petal. Wash with Bestine and a cotton swab.

15. Layer with Deco Pink. Burnish with French Gray 10%, White.

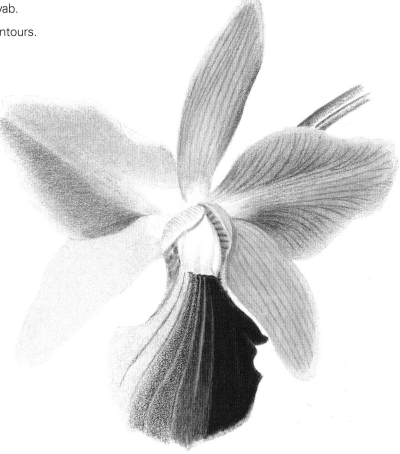

VINE

16. Lightly burnish with Olive Green, Apple Green, leaving highlights free of color. Sharpen edges with Olive Green (Verithin) or True Green (Verithin).

pansy

COLOR PALETTE

Jasmine

Cream

Spanish Orange

Sunburst Yellow

Canary Yellow

Dark Cadmium Yellow
(Polychromos)

Light Chrome Yellow
(Polychromos)

White

French Grey 10%

French Grey 20%

Warm Grey 90%

Black Grape

Violet

Dahlia Purple

Tuscan Red

Imperial Violet

Deep Cobalt Green
(Polychromos)

Olive Green

Lime Peel

Olive Green (Verithin)

PETALS

1. Outline perimeter of pansy, then layer with Jasmine, Cream. Wash with Bestine and a cotton swab.

2. Layer Spanish Orange, Sunburst Yellow, Canary Yellow. Wash with Bestine and a cotton swab.

3. Burnish yellow areas not to be covered by purple with Sunburst Yellow (bottom petal only), Canary Yellow, Dark Cadmium Yellow (Polychromos), Light Chrome Yellow (Polychromos), White. Burnish shadows and center with French Grey 20%, 10%. Burnish dark variegations with Warm Grey 90%, Black Grape. Randomly layer purple areas with Black Grape, Violet, Dahlia Purple, Tuscan Red. Randomly burnish purple areas on petal tips with White. Burnish lighter inner portions with Cream and inner edges with Light Chrome Yellow (Polychromos). Burnish bottom petal with Violet, Dahlia Purple, Tuscan Red. Randomly burnish purple areas at center of petals with White, Dahlia Purple, Tuscan Red. Burnish dark variegations with Black Grape.

4. Layer violet petals with Black Grape, Violet, Dahlia Purple, Imperial Violet. Smudge lighter areas of petals with a dry cotton swab. Layer dark areas with Black Grape, Violet, Dahlia Purple. Burnish smudged areas and top of dark area with White. Burnish dark areas with Black Grape, Violet, Dahlia Purple. Repeat burnishing with White, Black Grape, Violet and Dahlia Purple as necessary.

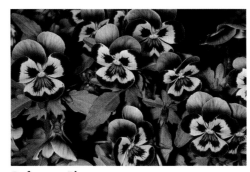

Reference Photo

1

2

3

4

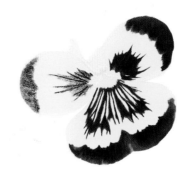

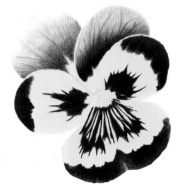

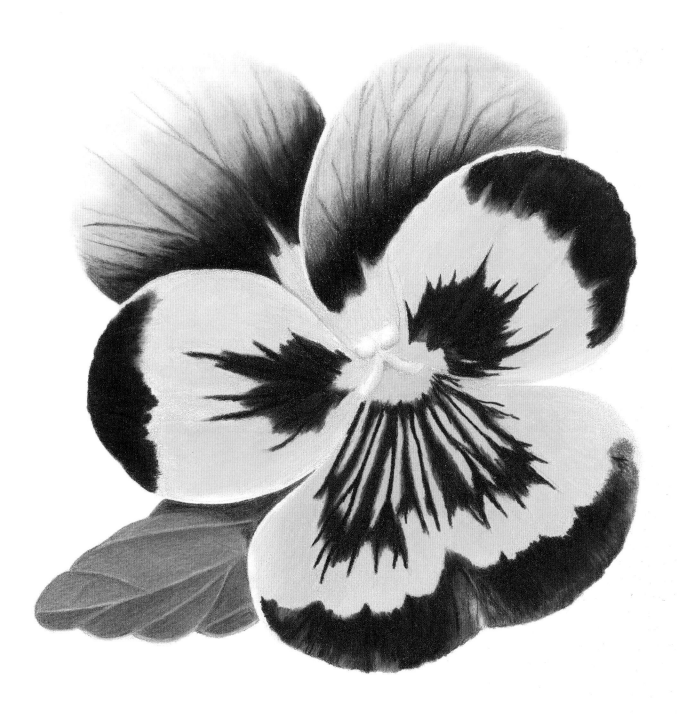

LEAF

5. Layer shadow with Warm Grey 90% and dark values with Deep Cobalt Green (Polychromos). Layer Olive Green, Lime Peel. Lightly burnish dark values with Lime Peel and light values with Cream. Burnish dark values with Olive Green and light values with Lime Peel. Sharpen edge with Olive Green (Verithin).

passion flower

COLOR PALETTE

French Grey 10%
French Grey 20%
French Grey 30%
Light Green (Polychromos)
Lavender
Greyed Lavender
Rosy Beige

Pink Rose
Olive Green
Olive Green (Verithin)
Spanish Orange
Spanish Orange
 (Verithin)
Black Grape

Violet
White
Violet (Verithin)
Parma Violet Verithin)
White (Verithin)
Olive Yellow (Pablo)
Cool Grey 90%

Deep Cobalt Green
 (Polychromos)
Grass Green
Apple Green
Cream
True Green (Verithin)
Tuscan Red

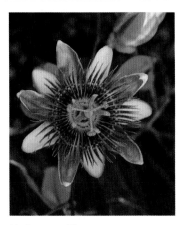

Reference Photo

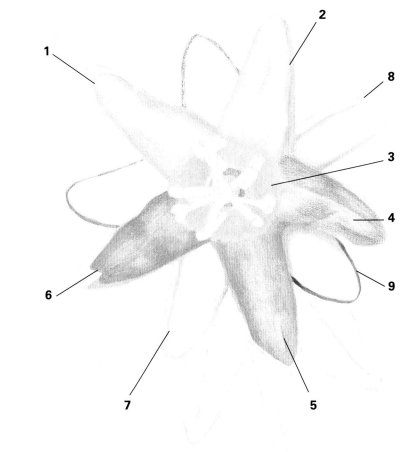

FLOWER

1. Layer dark values with French Grey 20%, 10%.

2. Wash with Bestine and a no. 8 brush.

3. Layer center green area (not including pistils) with Light Green (Polychromos), French Grey 20%. Wash with Bestine and a no. 6 brush. Lightly burnish with Light Green (Polychromos).

4. Layer lavender petals with Lavender, Greyed Lavender, Rosy Beige, Pink Rose.

5. Wash with Bestine and a no. 6 brush.

6. Lightly burnish with Lavender, Greyed Lavender, Rosy Beige, Pink Rose.

7. Layer white petals with French Grey 30%, 20%, 10%.

8. Wash with Bestine and a no. 6 brush.

9. Layer green-edged white petals with Olive Green. Burnish with French Grey 10%. Sharpen edges with Olive Green (Verithin).

10. Burnish yellow area of pistils with Spanish Orange. Sharpen edges with Spanish Orange (Verithin).

11. Burnish thin petals with Black Grape, Violet, Lavender, leaving small highlight area free of color. Burnish all except dark area with White, dragging color into highlight area. Burnish with Violet (Verithin) and Parma Violet (Verithin). Sharpen dark edges with Violet (Verithin) and light edges with White (Verithin).

12. Layer pistils with Olive Green (Verithin), Olive Yellow (Pablo), Light Green (Polychromos). Lightly burnish lighter areas with White. Stipple with Violet (Verithin).

13. Burnish variegations in center with Violet (Verithin).

LEAVES AND STEM

14. Layer shadows with Cool Grey 90%. Layer Deep Cobalt Green (Polychromos), Grass Green, Apple Green.

15. Dab with Bestine and a no. 6 brush.

16. Burnish with Cream, except darkest values.

17. Burnish Grass Green, Apple Green. Sharpen edges with True Green (Verithin).

18. Repeat steps 14-17 for stem, adding Tuscan Red to the layering sequence described in step 14.

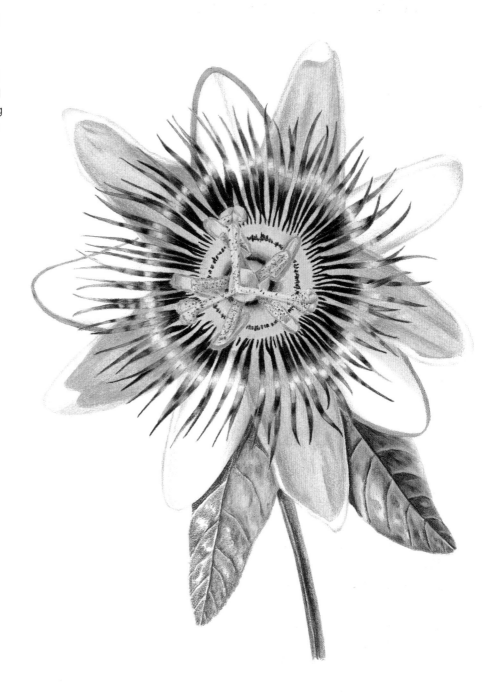

peony By Terry Sciko

COLOR PALETTE

(Painted on Crescent mat board, Williamsburg Green)

White
Blush Pink

Indigo Blue
Black Grape
Magenta

Hot Pink
Crimson Lake

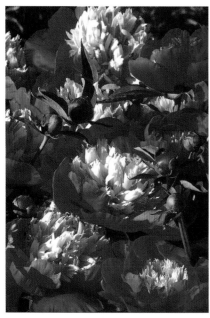

Reference Photo

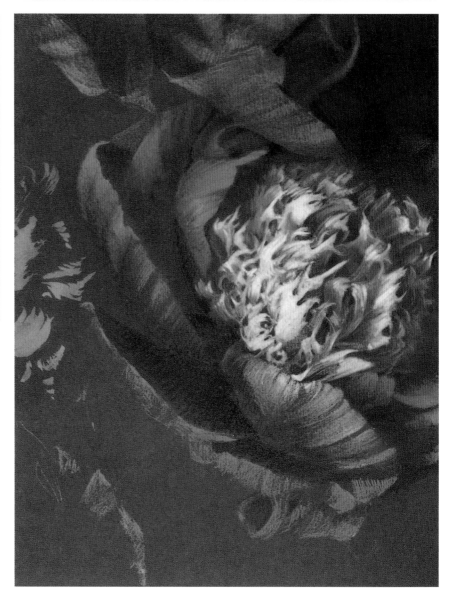

CENTER

1. Lay out with White.

2. Brush highlights with bleach, using a soft brush with light strokes.

3. Lightly layer highlights with White (heavier in bleached area), Blush Pink.

4. Layer shadows with Indigo Blue, Black Grape. Burnish with Magenta.

PETALS

5. Lightly layer highlights with White, Hot Pink. Lightly layer Magenta, Crimson Lake, leaving paper free of color for shadows. Burnish with cheesecloth.

6. Layer shadows with Indigo Blue, Black Grape. Burnish with cheesecloth.

petunia with dusty miller

COLOR PALETTE

Violet	Cool Grey 30%	Violet (Verithin)	Mulberry
Black Grape	Cool Grey 50%	Deco Pink	Magenta
Cool Grey 20%	Cool Grey 90%	Burnt Carmine (Polychromos)	White
	Pink		Black (Verithin)

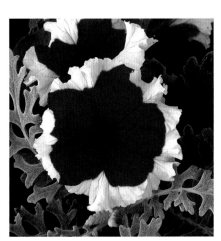

Reference Photo

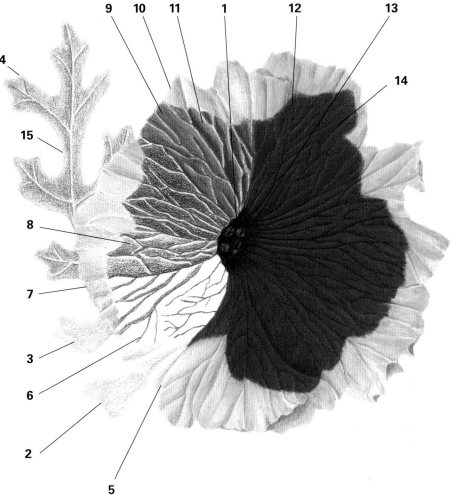

1. Burnish with Violet, Black Grape. Wash with Bestine and a no. 4 brush.

2. Layer with Cool Grey 30%.

3. Dab with Bestine and a cotton swab.

4. Layer with Cool Grey 90%.

5. Layer dark values with Cool Grey 20%. Wash with Bestine and a cotton swab. Layer dark values with Pink. Wash with Bestine and a cotton swab.

6. Impress veins with Violet (Verithin).

7. Lightly burnish with Deco Pink.

8. Layer Burnt Carmine (Polychromos), Mulberry, Magenta, leaving areas adjacent to veins free of color.

9. Burnish with White, dragging color into areas adjacent to veins.

10. Burnish with White. Repeat, beginning with Pink, as necessary.

11. Lightly burnish with Mulberry.

12. Burnish with Magenta using heavy pressure.

13. Lightly erase with sharpened imbibed eraser strip in an electric eraser. Dab erased areas with Bestine and a cotton swab. Burnish with Cool Grey 50%, Black Grape.

14. Redraw veins with Black (Verithin).

15. Lightly dab with Bestine and a no. 4 brush.

petunia *By Edna Henry*

FLOWER

1. Layer Pink Madder Lake, adding more layers in shadow areas. Layer center with Cadmium Yellow, Light Green.

2. Layer Lavender (Prismacolor). Lightly burnish with White (Prismacolor). Layer darker values with Purple Violet.

3. Layer Light Purple Pink, Magenta. Layer shadows with Dahlia Purple (Prismacolor).

4. Lighten highlights with kneaded eraser.

LEAVES

5. Layer Cream, Cadmium Yellow, Light Green. Layer shadows with Light Phthalo Green, Earth Green Yellowish.

6. Layer Light Phthalo Blue, Emerald Green. Layer shadows with Bluish Turquoise.

7. Layer Bluish Turquoise, Pink Madder Lake. Layer shadows with Hooker's Green, May Green.

8. Lightly layer shadows with Pink Madder Lake, Dahlia Purple (Prismacolor).

COLOR PALETTE

(All colors are Polychromos unless otherwise noted.)

Pink Madder Lake
Cadmium Yellow
Light Green
Lavender (Prismacolor)
White (Prismacolor)
Purple Violet
Light Purple Pink
Magenta

Dahlia Purple (Prismacolor)
Cream
Light Phthalo Green
Earth Green Yellowish
Light Phthalo Blue
Emerald Green
Bluish Turquoise
Hooker's Green
May Green

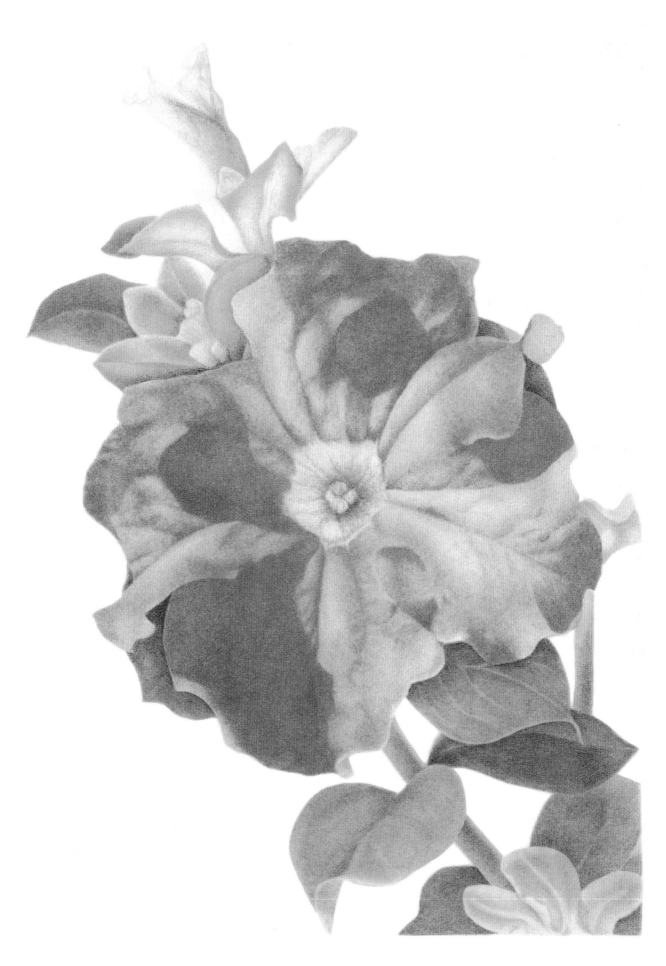

poinsettia *By Sherry Loomis*

COLOR PALETTE

French Grey 90%	Magenta	Deco Pink	Warm Grey 90%
Black Grape	Grass Green	Indigo Blue	Yellow Chartreuse
Yellowed Orange			

1. Layer dark values with French Grey 90%, Black Grape.

2. Layer entire area with Yellowed Orange.

3. Layer center of buds with Magenta.

4. Layer Grass Green.

5. Layer shadows and veins with French Grey 90%, leaving lightest values free of color.

6. Layer Black Grape, leaving lightest values free of color.

7. Layer color-free areas with Deco Pink.

8. Layer areas in step 7 with Magenta.

9. Layer darkest shadow areas with Indigo Blue.

10. Layer dark values with French Grey 90%, Warm Grey 90%, Grass Green.

11. Layer veins with Yellow Chartreuse.

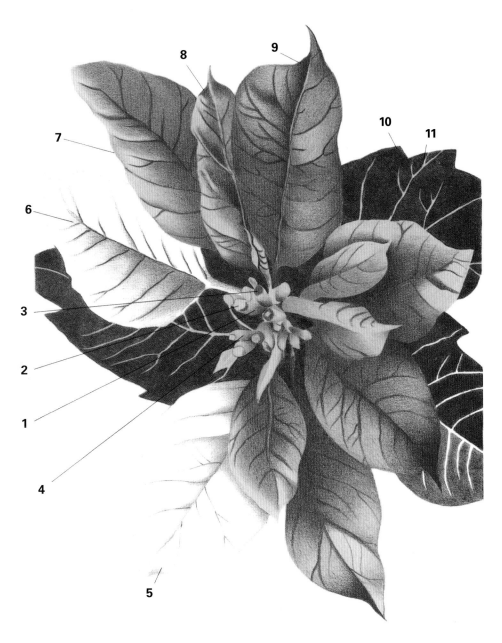

poppy

COLOR PALETTE

Tuscan Red	Black (Verithin)	French Grey 20%	Apple Green
Crimson Red	Tuscan Red (Verithin)	French Grey 70%	Lime Peel
Scarlet Lake	Crimson Lake	French Grey 90%	Yellow Chartreuse
Poppy Red	Crimson Red (Verithin)	Cool Grey 90%	Cream
White	Pale Vermilion (Verithin)	Dark Green	Olive Green (Verithin)
Black	French Grey 10%	Olive Green	True Green (Verithin)

PETALS

1. Layer shadows with Tuscan Red. Layer Crimson Red, Scarlet Lake, Poppy Red.

2. Burnish with White, except shadows and dark values.

3. Burnish with Crimson Red, Scarlet Lake, Poppy Red. Repeat burnishing as necessary.

4. Layer Black, Tuscan Red. Burnish with Black (Verithin), Tuscan Red (Verithin) over black variegations only.

5. Burnish with Crimson Lake, Crimson Red. Sharpen edges with Crimson Red (Verithin) or Pale Vermilion (Verithin).

CENTER

6. Burnish red bands with Crimson Red (Verithin) and Pale Vermilion (Verithin).

7. Layer gradation of French Grey 90%, 70%, 20%.

8. Burnish with French Grey 10%. Burnish with French Grey 90%, 70%, 20%. Repeat as necessary.

9. Carefully scrape with a new #11 craft knife blade.

10. Draw the stamen with Black (Verithin), leaving some scraped areas free of color.

LEAF, STEM AND BUD

11. Layer shadows with Cool Grey 90%. Layer Dark Green, Olive Green, Apple Green, Lime Peel, Yellow Chartreuse. Wash with Bestine and a no. 8 brush. Burnish with Cream. Burnish with Lime Peel and Yellow Chartreuse. Sharpen edges with Olive Green (Verithin) or True Green (Verithin).

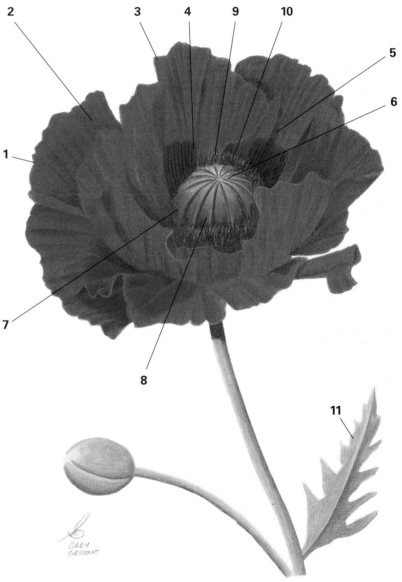

primrose *By Sherry Loomis*

COLOR PALETTE

French Grey 90%	Hot Pink	Pale Vermilion	Black
Black Grape	Deco Pink	Bronze	Peacock Green
Raspberry	Yellowed Orange	Crimson Red	Grass Green

1. Layer French Grey 90%. Leave lightest values free of color.

2. Layer Black Grape, leaving lightest values free of color.

3. Layer Raspberry.

4. Layer Hot Pink, Deco Pink.

5. Layer Yellowed Orange.

6. Layer Pale Vermilion.

7. Layer Bronze.

8. Layer Crimson Red over the darkest petal areas.

9. Layer tiny amounts of Black to deepen shadows under petals.

10. Layer French Grey 90%, Black Grape, Bronze.

11. Layer dark values with French Grey 90%, leaving paper free of color for highlights.

12. Layer Black Grape.

13. Layer Peacock Green.

14. Layer highlights with Yellowed Orange.

15. Layer Grass Green lightly in highlights.

rhododendron

COLOR PALETTE

Cool Grey 20%	Tuscan Red	Scarlet Lake
Cool Grey 50%	Raspberry	Deep Cobalt Green (Polychromos)
Cool Grey 90%	Process Red (Verithin)	Grass Green
Process Red	Olive Yellow (Pablo)	Lime Peel
Hot Pink	Pale Yellow (Pablo)	Grass Green (Verithin)
Deco Pink	Warm Grey 20% (Verithin)	
White		

Reference Photo: Flowers

Reference Photo: Leaves

PETALS

1. Layer shadows with Cool Grey 50%. Wash with Bestine and a cotton swab or small brush.

2. Layer Process Red, Hot Pink, Deco Pink.

3. Burnish with White.

4. Burnish with Hot Pink, Deco Pink.

5. Burnish variegations with Tuscan Red, Raspberry. Sharpen edges with Process Red (Verithin).

PISTIL AND STAMEN

6. Layer Deco Pink, Cool Grey 20%, Olive Yellow (Pablo). Burnish with Pale Yellow (Pablo).

7. Draw details with Warm Grey 20% (Verithin).

BUDS AND STEM

8. Layer Scarlet Lake, Process Red, Hot Pink, Deco Pink.

9. Burnish with White. Burnish with Scarlet Lake, Process Red, Hot Pink, Deco Pink.

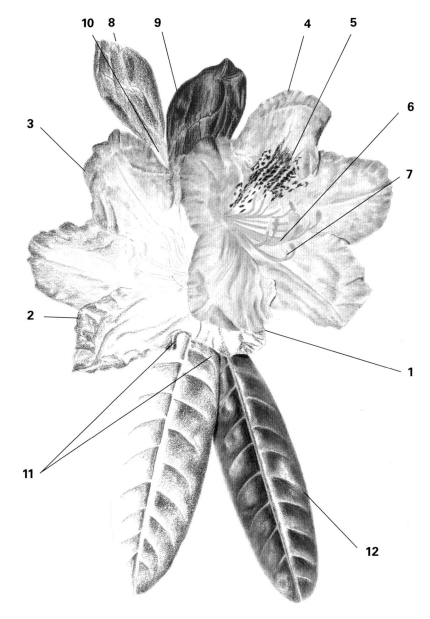

10. Layer Olive Yellow (Pablo). Burnish with Pale Yellow (Pablo). Sharpen edges with Process Red (Verithin).

LEAF

11. Layer shadows with Cool Grey 90%. Layer Deep Cobalt Green (Polychromos), Grass Green, Lime Peel. Leave highlight areas free of color.

12. Burnish with Pale Yellow (Pablo). Burnish with Deep Cobalt Green (Polychromos), Grass Green, Lime Peel. Sharpen edges with Grass Green (Verithin).

rose

COLOR PALETTE

Cool Grey 30%

Cool Grey 90%

Greyed Lavender

Pink Rose

Deco Pink

White

Tuscan Red

Permanent Carmine
(Polychromos)

Pink Carmine
(Polychromos)

Light Purple Pink
(Polychromos)

Process Red (Verithin)

Deco Pink (Verithin)

Deep Cobalt Green
(Polychromos)

Grass Green

Lime Peel

Cream

Grass Green (Verithin)

Light Umber

Tuscan Red (Verithin)

Reference Photo

1. Layer shadows in petals with Cool Grey 30%. Wash with Bestine and a cotton swab or no. 4 brush in tight areas.

2. Layer dark values with Cool Grey 90%. Layer shadows with Greyed Lavender. Wash with Bestine and a cotton swab or no. 4 brush in tight areas.

3. Layer dark values with Pink Rose and light values with Deco Pink. Burnish with White, Pink Rose, Deco Pink.

4. Layer dark pink shadows with Tuscan Red. Layer Permanent Carmine (Polychromos), Pink Carmine (Polychromos), Light Purple Pink (Polychromos), Pink Rose.

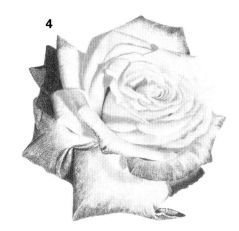

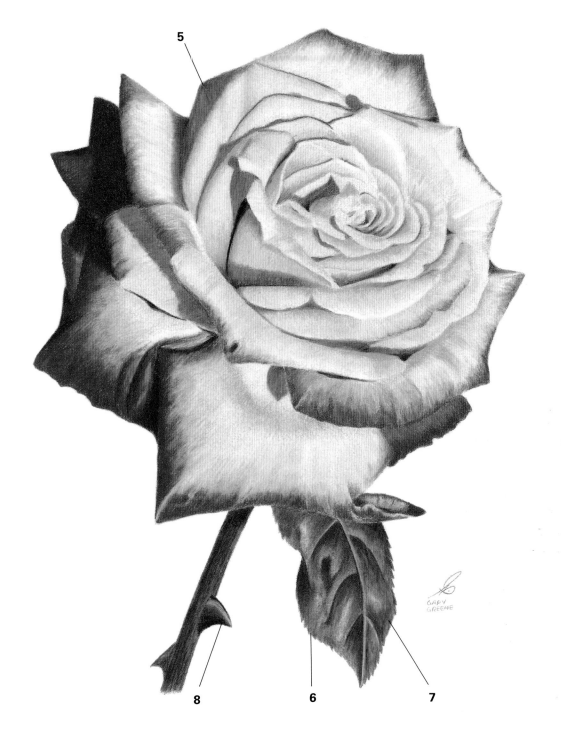

5. Layer light pink shadows with Tuscan Red. Burnish with Pink Rose. Sharpen edges with Process Red (Verithin) or Deco Pink (Verithin).

6. Layer dark values in leaf and stem with Cool Grey 90%. Layer Deep Cobalt Green (Polychromos), Grass Green, Lime Peel and Tuscan Red on the stem, leaving highlights free of color.

7. Lightly burnish with Cream. Burnish with Deep Cobalt Green (Polychromos), Grass Green, Lime Peel and Tuscan Red on the stem only. Sharpen edges with Grass Green (Verithin).

8. Layer dark values in thorns with Deep Cobalt Green (Polychromos). Layer Tuscan Red, Light Umber. Burnish with Cream. Lightly burnish Tuscan Red, Light Umber. Sharpen edges with Tuscan Red (Verithin).

ANOTHER
rose By Sherry Loomis

COLOR PALETTE

French Grey 90% Crimson Red Peacock Green

Black Grape Indigo Blue Spring Green

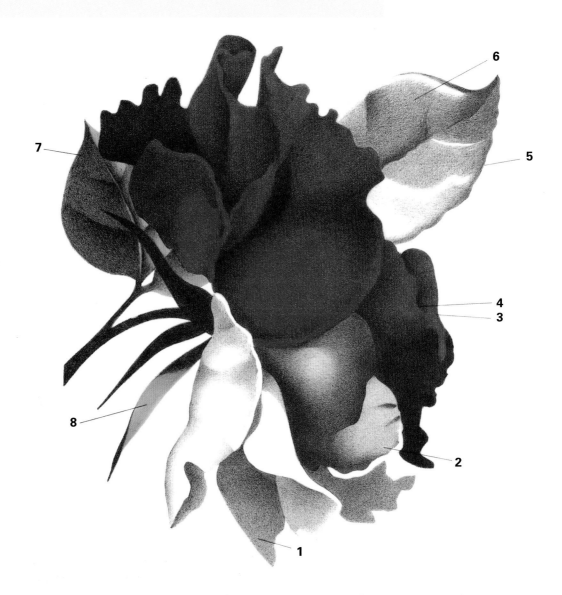

PETALS

1. Layer shadows with French Grey 90%, leaving lightest values free of color.

2. Layer Black Grape, leaving lightest values free of color.

3. Layer Crimson Red over entire blossom.

4. Layer darkest shadow areas with Indigo Blue.

STEM AND LEAVES

5. Layer shadow with French Grey 90%, leaving lightest values free of color.

6. Layer Black Grape, leaving lightest values free of color.

7. Layer dark values with Peacock Green.

8. Layer with Spring Green, slightly overlapping with the edges of areas completed in steps 1–3.

slipperwort (calceolaria)

COLOR PALETTE

French Grey 10%
French Grey 20%
French Grey 50%
Goldenrod

Spanish Orange
Sunburst Yellow
Tuscan Red
Crimson Lake
Crimson Red

Crimson Red (Verithin)
Spanish Orange
 (Verithin)
White (Verithin)
Apple Green

Lime Peel
Olive Green
Cream
True Green (Verithin)

Reference Photo

1. Layer upper petals with French Grey 10%, 20%, 50%, leaving small areas free of color. Layer Goldenrod. Wash with Bestine and a no. 6 brush. Wash lower petals with Bestine and a cotton swab. Lightly layer lower petals with French Grey 20%, Goldenrod, Spanish Orange. Wash with Bestine and a highly saturated no. 6 brush.

2. Layer Spanish Orange, Sunburst Yellow. Wash with Bestine and a cotton swab (use a no. 4 brush in upper petals). Repeat as necessary for complete coverage.

3. Layer small amounts of Tuscan Red in darker values of red variegations. Burnish with Crimson Lake,

Crimson Red. Sharpen edges of variegations with Crimson Red (Verithin) and edges of petals with Spanish Orange (Verithin).

4. Impress veins with White (Verithin), keeping pencil sharp at all times. Layer Apple Green, Lime Peel.

5. Layer Olive Green, Apple Green, Lime Peel. Dab with Bestine and a highly saturated no. 6 brush. Burnish with Cream, Olive Green, Apple Green, Lime Peel. Repeat dabbing with Bestine and burnishing as necessary. Sharpen edges with True Green (Verithin).

salpiglossis (painted tongue)

COLOR PALETTE

Spanish Orange

Sunburst Yellow

Tuscan Red

Crimson Red

Scarlet Lake

Pompeian Red (Polychromos)

Pale Geranium Lake (Polychromos)

White

Tuscan Red (Verithin)

Olive Black (Pablo)

Olive Green

Cream

Goldenrod

Apple Green

Olive Green (Verithin)

Reference Photo

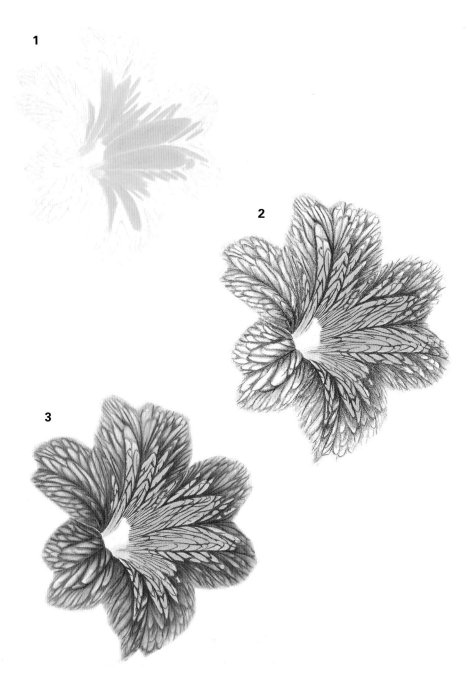

PETALS

1. Layer Spanish Orange, Sunburst Yellow. Wash with Bestine and a cotton swab.

2. Layer Tuscan Red, Crimson Red, Scarlet Lake, Pompeian Red (Polychromos), Pale Geranium Lake (Polychromos). Lightly smudge white areas with dry cotton swab.

3. Burnish with White.

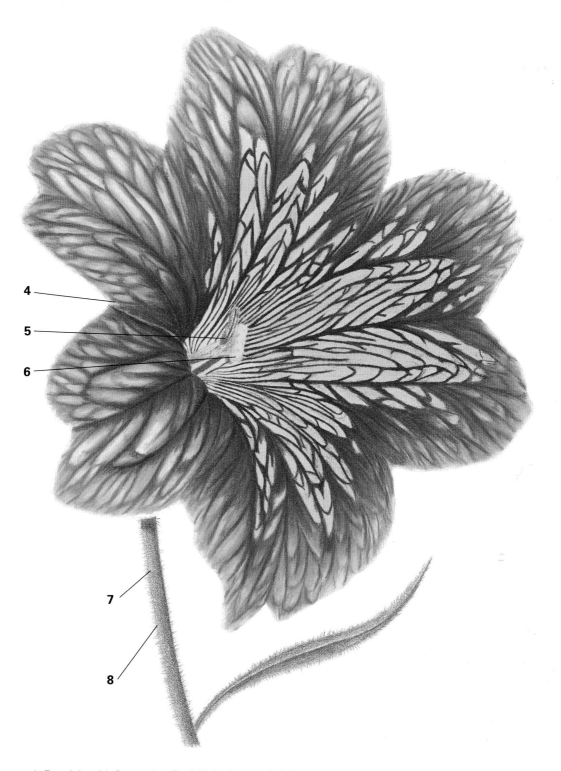

4. Burnish with Pompeian Red (Polychromos). Sharpen dark red areas adjacent to yellow variegations with Tuscan Red (Verithin).

CENTER

5. Layer Olive Black (Pablo), Olive Green. Lightly burnish stem only with Cream.

6. Lightly burnish with Goldenrod, Sunburst Yellow.

LEAVES AND STEM

7. Layer Olive Black (Pablo), Olive Green, Apple Green.

8. Using short, light strokes, add cilia with Olive Green (Verithin).

shasta daisy

COLOR PALETTE

Cool Grey 10%

Cool Grey 20%

Cool Grey 50%

Cool Grey 70%

Goldenrod

Sunburst Yellow

Dark Brown (Verithin)

Goldenrod (Verithin)

Cool Grey 70% (Verithin)

Warm Grey 20% (Verithin)

White (Verithin)

Deep Cobalt Green
(Polychromos)

Olive Green

Lime Peel

Olive Green (Verithin)

True Green (Verithin)

CENTER

1. Layer Cool Grey 50%.

2. Layer Goldenrod.

3. Wash center with Bestine and a no. 8 brush.

4. Layer Sunburst Yellow.

5. Wash center with Bestine and a no. 8 brush.

6. Draw circles in darker area of center with Dark Brown (Verithin).

7. Draw circles in lighter area of center with Goldenrod (Verithin).

8. Lightly erase lighter area of center with kneaded eraser. Repeat step 7.

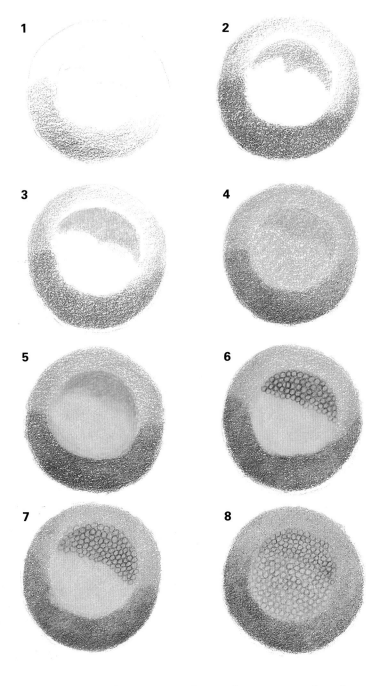

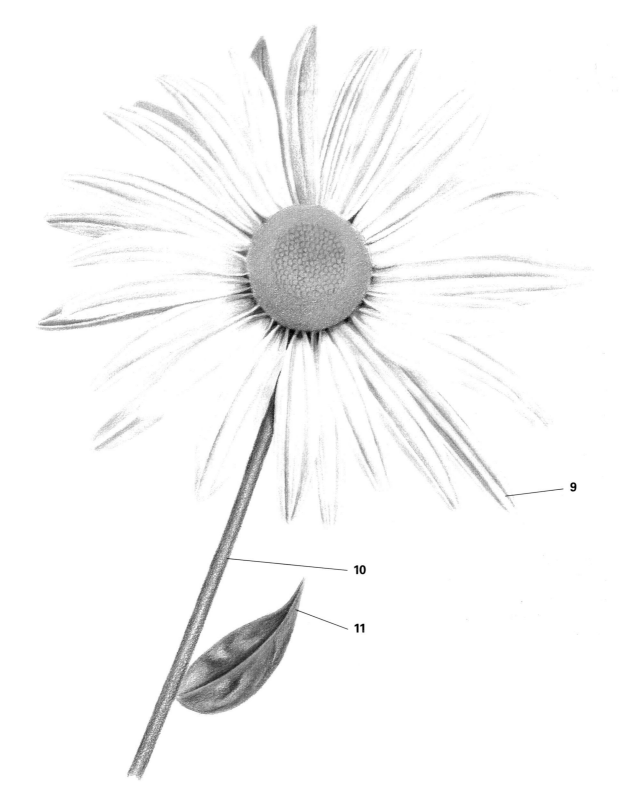

PETALS

9. Layer dark values with Cool Grey 70% (Verithin), Warm Grey 20% (Verithin), Cool Grey 50%. Layer Cool Grey 20%, 10%. Wash with Bestine and a no. 4 brush. Lightly burnish with White (Verithin).

STEM AND LEAF

10. Layer shadows with Cool Grey 70%. Layer Deep Cobalt Green (Polychromos), Olive Green, Lime Peel.

11. Lightly burnish with Cool Grey 10%, except dark values. Lightly burnish with Olive Green, Lime Peel, True Green (Verithin). Sharpen edges with Olive Green (Verithin) or True Green (Verithin).

snapdragon

COLOR PALETTE

Henna	Deco Peach	French Grey 20%	Cream
Rosy Beige	Deco Pink	French Grey 30%	Olive Green
Process Red	White	Goldenrod	Green Ochre (Pablo)
Pink	Sunburst Yellow	Lime Peel	Olive Yellow (Pablo)
Pink Rose	French Grey 10%		

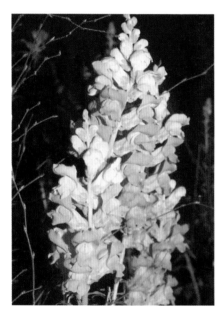

Reference Photo

PETALS

1. Layer shadows with Henna. Layer dark values with Rosy Beige. Layer Process Red (except lighter petals), Pink. Wash with Bestine and a no. 6 brush.

2. Layer Pink Rose, Deco Peach, Deco Pink. Wash with Bestine and a no. 6 brush, and lightly burnish this area with White.

3. Lightly burnish with Pink Rose, Deco Peach, Deco Pink.

4. Layer Sunburst Yellow. Wash with Bestine and a no. 6 brush.

BUDS

5. Layer French Grey 30%, 20%, 10%, Goldenrod.

6. Wash with Bestine and a no. 6 brush.

7. Lightly layer with Lime Peel.

8. Wash with Bestine and a no. 6 brush.

9. Lightly burnish with Cream.

STEMS AND LEAVES

10. Layer dark values with Olive Green. Layer Lime Peel, Green Ochre (Pablo), Olive Yellow (Pablo).

11. Wash with Bestine and a no. 4 brush.

12. Lightly burnish with Cream.

13. Lightly burnish with Lime Peel, Olive Yellow (Pablo).

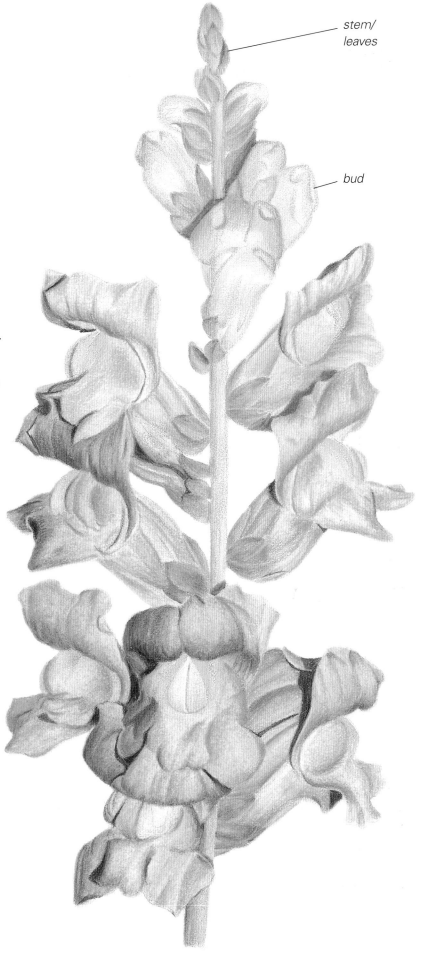

stem/ leaves

bud

sunflower *By Judy McDonald*

COLOR PALETTE

Tuscan Red	Pale Vermilion	Yellow Chartreuse	Spring Green
Dark Purple	Mineral Orange	Peacock Green	Light Green
Poppy Red	Burnt Ochre	Violet	Jasmine
Canary Yellow	Indigo Blue	Grass Green	

PETALS

1. Layer all with Tuscan Red, leaving highlights free of color.

2. Layer darkest values with Dark Purple and the shadows with Poppy Red.

3. To finish the petals, burnish with Canary Yellow. Lightly burnish shadows with Pale Vermilion. Burnish some highlights with Canary Yellow, leaving others free of color. Burnish edges with Mineral Orange, Poppy Red, Dark Purple.

CENTER

4. Layer outer ring with Burnt Ochre.

5. Lightly burnish inner circle with Indigo Blue, leaving gap concentric with outer ring free of color.

6. Lightly burnish gap described in step 5 with Yellow Chartreuse, dragging small amounts of color from outer and inner areas.

7. Layer entire center, except step 6, with varying amounts of Indigo Blue, Dark Purple, Poppy Red.

LEAVES

8. Layer darkest values with Peacock Green, Indigo Blue.

9. Layer shadows with Violet. Layer highlight areas with Grass Green. Burnish edges with Spring Green.

10. Layer highlights with Light Green. Burnish veins and edges with Jasmine.

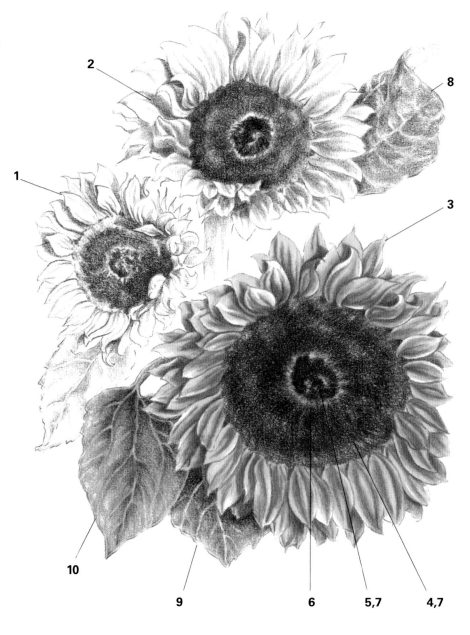

trillium

COLOR PALETTE

Cool Grey 70% (Verithin)
Cool Grey 10%
Cool Grey 20%
Cool Grey 50%

Goldenrod (Verithin)
Sunburst Yellow
Canary Yellow
Warm Grey 20% (Verithin)

Deep Cobalt Green
(Polychromos)
Olive Black (Pablo)

Olive Green
Lime Peel
Olive Green (Verithin)

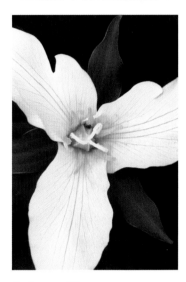

Reference Photo

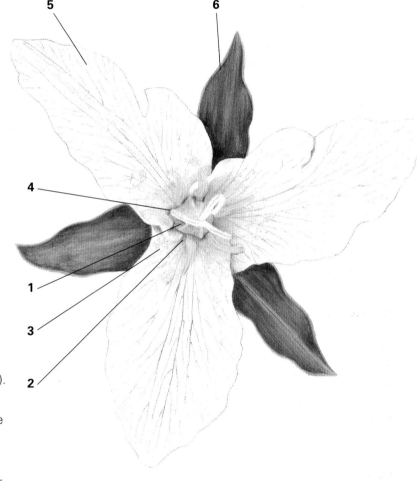

CENTER AND PETALS

1. Layer dark values with Cool Grey 70% (Verithin). Layer Cool Grey 50%, 20%, 10%. Smudge with a dry cotton swab. Wash with Bestine and a no. 4 brush.

2. Draw darker values with Goldenrod (Verithin). Burnish with Sunburst Yellow.

3. Layer with Canary Yellow. Wash with Bestine and a no. 4.

4. Draw darker values with Warm Grey 20% (Verithin). Wash with Bestine and a no. 4 brush, leaving some areas free of color.

5. Draw veins with Warm Grey 20% (Verithin), using lighter pressure at edge of petal.

LEAVES

6. Layer Deep Cobalt Green (Polychromos), Olive Black (Pablo), Olive Green, Lime Peel. Lightly burnish with Cool Grey 10%. Burnish with Olive Green, Lime Peel. Sharpen edges with Olive Green (Verithin).

tulip

COLOR PALETTE

Warm Grey 90% Sunburst Yellow White Deep Cobalt Green
Olive Green Crimson Red Crimson Red (Polychromos)
Spanish Orange Scarlet Lake (Verithin) French Grey 10%
Yellowed Orange Poppy Red Olive Green (Verithin)

FLOWER

1. Layer base of flower with Warm Grey 90%, Olive Green. Wash with Bestine and a no. 4 brush.

2. Layer Spanish Orange, Yellowed Orange, Sunburst Yellow.

3. Wash with Bestine and a cotton swab.

4. Layer dark values with Crimson Red. Layer Scarlet Lake, Poppy Red.

5. Burnish with White.

6. Burnish with Scarlet Lake, Poppy Red.

7. Burnish edge of red areas with Sunburst Yellow.

8. Layer variegations with Poppy Red. Sharpen variegations and edges with Crimson Red (Verithin).

STEM AND LEAVES

9. Layer dark values with Warm Grey 90%. Layer Deep Cobalt Green (Polychromos), Olive Green.

10. Burnish with French Grey 10%.

11. Burnish with Deep Cobalt Green (Polychromos), Olive Green. Sharpen edges with Olive Green (Verithin).

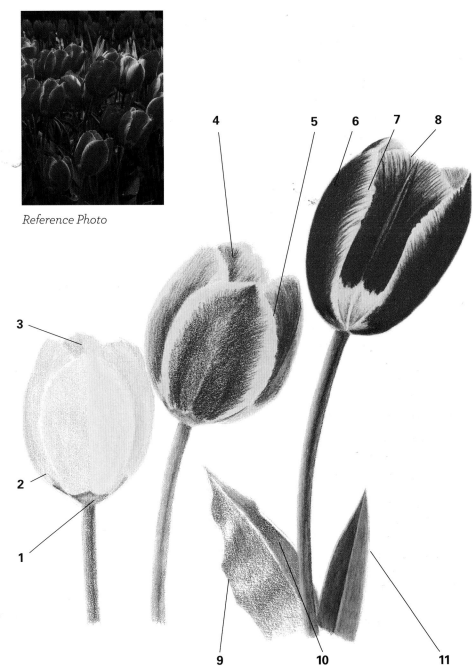

Reference Photo

ANOTHER *tulip* *By Kristy Kutch*

COLOR PALETTE

All colors are Polychromos unless otherwise noted.

Violet

Tuscan Red (Verithin)

Pink Carmine

Permanent Carmine

White (Prismacolor)

Scarlet Red

Rose Carmine

Black Grape (Prismacolor)

Pink Madder Lake

Indigo Blue (Prismacolor)

Deep Cobalt Green

Earth Green

Cream

Chrome Oxide Green

Grass Green (Verithin)

1. Lightly layer shadows with Violet. Layer edges with Tuscan Red (Verithin). Layer Pink Carmine, Permanent Carmine.

2. Burnish with White (Prismacolor). Sharpen edges with Tuscan Red (Verithin). Layer Scarlet Red, Rose Carmine. Burnish with White (Prismacolor).

3. Lightly layer shadows with Black Grape (Prismacolor). Layer Pink Carmine, Permanent Carmine, Scarlet Red, Rose Carmine. Lightly layer secondary reflections with Pink Madder Lake. Sharpen edges with Tuscan Red (Verithin).

4. Layer darker values with Black Grape (Prismacolor), Indigo Blue (Prismacolor). Layer middle values with Deep Cobalt Green. Layer light values and stems with Earth Green.

5. Impress veins with a 7H graphite pencil and drafting or tracing paper. Lightly burnish with Cream. Lightly burnish shadows with Black Grape (Prismacolor). Lightly burnish with Indigo Blue (Prismacolor), Deep Cobalt Green, Chrome Oxide Green, Earth Green. Repeat burnishing as necessary beginning with Cream. Sharpen edges with Grass Green (Verithin).

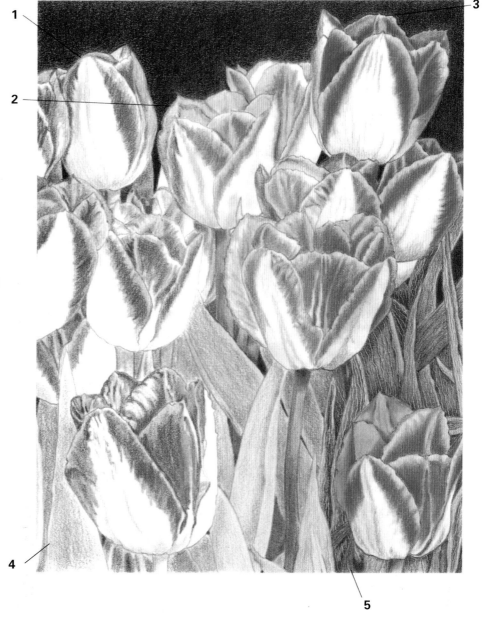

water lily

COLOR PALETTE

Spanish Orange

Sunburst Yellow

Apricot (Luminance)

Deco Peach

Scarlet Lake

Carmine Red

Blush Pink

Rosy Beige

Pink Rose

White

French Grey 50%

Clay Rose

Tuscan Red

Henna

Goldenrod (Verithin)

Goldenrod

Canary Yellow

Crimson Red (Verithin)

Olive Green

Lime Peel

Apple Green

Yellow Chartreuse

True Green (Verithin)

Olive Green (Verithin)

FLOWER

1. Lightly layer stamen with Spanish Orange, Sunburst Yellow.

2. Lightly layer Spanish Orange, Sunburst Yellow. Smudge with a dry cotton swab. Wash with Bestine and a cotton swab.

3. Lightly layer Apricot (Luminance), Deco Peach. Smudge with a dry cotton swab. Wash with Bestine and a cotton swab.

4. Layer Scarlet Lake, Carmine Red, Blush Pink, Rosy Beige, Pink Rose.

5. Burnish with White.

6. Lightly burnish with Scarlet Lake, Carmine Red, Blush Pink, Rosy Beige, Pink Rose.

7. Layer shadows on light pastel petals with French Grey 50%. Burnish with Clay Rose.

8. Burnish shadows in red areas with Tuscan Red or Henna.

9. Burnish stamen with Goldenrod (Verithin), Goldenrod, Canary Yellow.

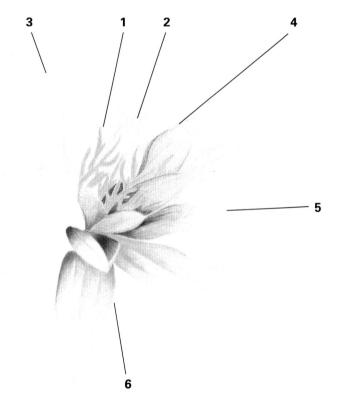

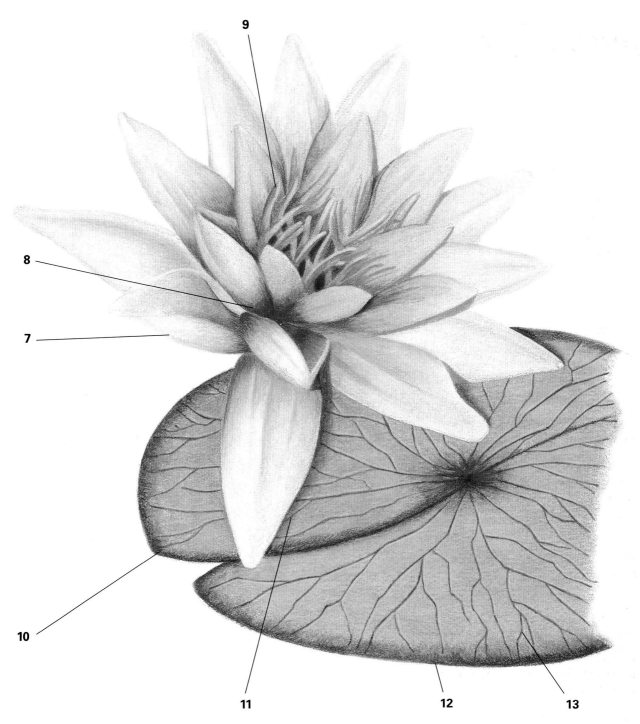

PAD

10. Layer edges and center with Henna, Clay Rose. Wash with Bestine and a no. 8 brush, using strokes emanating from or going toward the center. Burnish with Henna, Clay Rose. Sharpen edges with Crimson Red (Verithin).

11. Layer shadows with Olive Green. Wash with Bestine and a small brush. Layer Lime Peel, Apple Green, Yellow Chartreuse. Wash with Bestine and a no. 8 brush.

12. Burnish shadows with Olive Green. Lightly burnish with Lime Peel. Burnish with Yellow Chartreuse.

13. Draw veins with Henna. Burnish with Crimson Red (Verithin). Burnish vein highlights with White. Lightly burnish over with Yellow Chartreuse. Sharpen edges adjacent to petals with True Green (Verithin) or Olive Green (Verithin).

ANOTHER
water lily By Susan L. Brooks

COLOR PALETTE

(All colors are Derwent WS unless otherwise noted.)

Pink Madder Lake

Pink Rose (Prismacolor)

Pink (Prismacolor)

Deco Pink (Prismacolor)

Process Red (Verithin)

Magenta (Verithin)

Primrose Yellow

Magenta

Dark Purple (Prismacolor)

May Green

Bottle Green

Cedar Green

Jade Green

Aquamarine (Prismacolor)

Light Aqua (Prismacolor)

Emerald Green

Olive Green

Kingfisher Blue

FLOWER

1. Layer inside of petals with Pink Madder Lake, Pink Rose (Prismacolor), Pink (Prismacolor), Deco Pink (Prismacolor). Graduate as shown. Lightly burnish with Pink Madder Lake. Burnish with colorless blender. Sharpen edges with Process Red (Verithin) and Magenta (Verithin).

2. Outline petals with Primrose Yellow. Burnish with colorless blender.

3. Layer outside of petal with Magenta, Dark Purple (Prismacolor). Burnish with colorless blender. Repeat as necessary.

LEAVES

4. Layer May Green.

5. Layer shadows with Bottle Green. Layer inside with Cedar Green.

6. Lightly burnish highlights with Primrose Yellow. Repeat steps 4–6 as necessary.

7. Lightly burnish with Jade Green, Aquamarine (Prismacolor), Light Aqua (Prismacolor).

PAD

8. Layer Emerald Green. Burnish with colorless blender.

9. Layer randomly with Jade Green, May Green, Olive Green, Kingfisher Blue. Repeat as necessary.

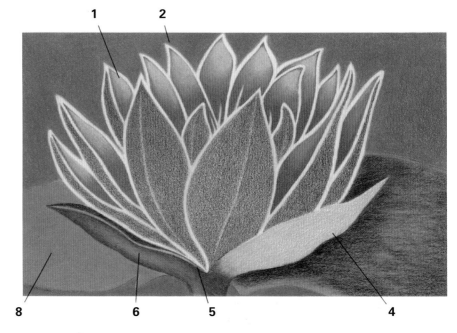

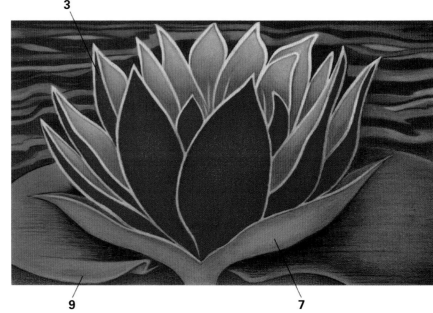

zinnia

COLOR PALETTE

Sunburst Yellow

Crimson Red

Permanent Carmine
(Polychromos)

Tuscan Red

Goldenrod

Carmine Red

White

Crimson Red (Verithin)

Cool Grey 10%

Cool Grey 90%

Dark Green

Olive Green

Lime Peel

Olive Yellow (Pablo)

Olive Green (Verithin)

CENTER

1. Layer Sunburst Yellow. Wash with Bestine and a no. 8 brush.

2. Layer Crimson Red, Permanent Carmine (Polychromos). Dab with Bestine and a no. 8 brush, leaving areas of yellow showing through. Layer upper center area with Tuscan Red.

3. Burnish lower center area randomly with Tuscan Red. Dab with Bestine and a no. 8 brush, leaving areas of yellow showing through.

4. Define yellow petals with Goldenrod. Burnish with Sunburst Yellow.

PETALS

5. Layer dark values with Tuscan Red. Layer Crimson Red, Permanent Carmine (Polychromos), Carmine Red.

6. Burnish with White.

7. Burnish with Crimson Red, Permanent Carmine (Polychromos), Carmine Red. Repeat as necessary. Sharpen edges with Crimson Red (Verithin).

LEAF AND STEM

8. Layer Cool Grey 90%, Dark Green, Olive Green, Lime Peel, Olive Yellow (Pablo).

9. Burnish with Cool Grey 10%. Burnish with Olive Green, Lime Peel, Olive Yellow (Pablo). Repeat as necessary. Sharpen edges with Olive Green (Verithin).

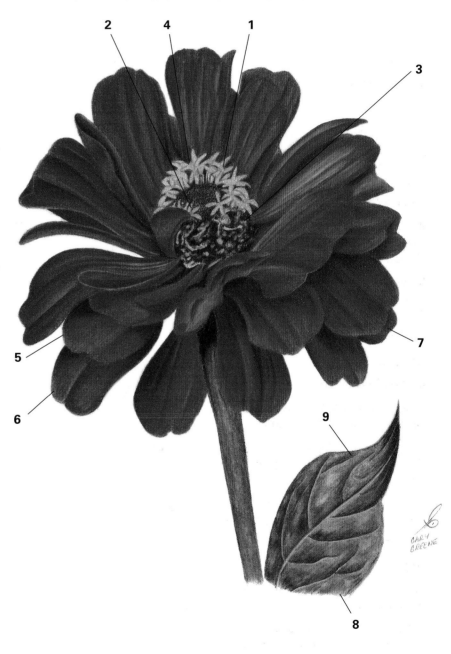

contributing artists' biographies

Susan L. Brooks is a signature member of the Colored Pencil Society of America (CPSA) where she served on the National Governing Board as their exhibition director and then for two terms as the national president. She lives in The Woodlands, Texas, and teaches on-going colored pencil classes to adults on a year-round basis. She earned her bachelor of fine arts degree in painting, drawing and graphics, and another bachelor's degree in art education from Ohio State University. Her work has won numerous awards in shows around the country, including *Art Calendar*'s Thunder and Lightning, and CPSA International Exhibition. Her work has also appeared in *The Artist's Magazine* and various other books on colored pencil, including *The Colored Pencil Artist's Drawing Bible* (Chartwell Books). Besides art, Brooks also teaches Anusara yoga. To see more of her work, go to susanbrooksfineart.com.

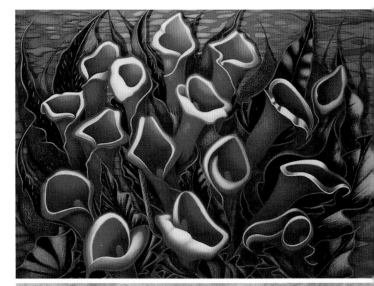

Edna Henry is a graduate of Willamette University in Salem, Oregon. Henry loved to draw and paint as a child but had no formal art instruction until college, where she took art classes while pursuing other studies. While involved with oil painting and watercolor, she struggled to overcome her realistic bent, which seemed to be unacceptable in an art world committed to "less is more." The struggle ended when she discovered colored pencils, a medium that seemed to insist on realism. She studied colored pencil, among other mediums, with Bet Borgeson, Bernard Poulin and Gary Greene. Her work has appeared in *The Best of Colored Pencil 2* (Rockport) and *Creative Colored Pencil: The Step-by-Step Guide & Showcase* (Rockport) and has been exhibited in such prestigious events as the 1993 and 1994 CPSA International Exhibitions.

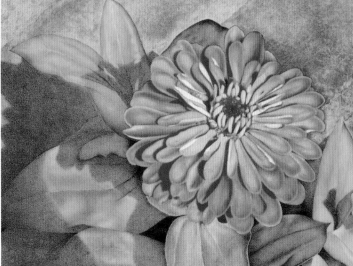

Kristy Ann Kutch lives in Michigan City, Indiana, and received both bachelor's and master's degrees in elementary education from Purdue University. Urged into taking watercolor classes, Kutch eventually found her artistic niche in a colored pencil drawing class. With her art featured in twelve books, Kutch also wrote her own book, *Drawing and Painting With Colored Pencil* (Watson-Guptill). She is a charter member and signature member of the Colored Pencil Society of America and has taught colored pencil workshops since 1991. Her favorite subjects include flowers and landscapes created using colored pencils and water-soluble colored pencils and wax pastels. Visit her website at artshow.com/kutch.

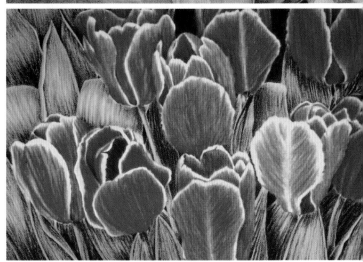

Sherry Loomis received her bachelor of arts degree at California Polytechnic State University, and she studied art at California State University, Long Beach, and San Francisco State University. She is a Charter Member of the CPSA and an Associate Member of the Society of Children's Book Writers and Illustrators. Her delicately layered paintings have achieved recognition in international, national, and local exhibitions, including the 1993 CPSA International Exhibition and the Realism '94 Exhibition. Loomis is featured in *Creative Colored Pencil: The Step-by-Step Guide & Showcase* (Rockport) and *The Best of Colored Pencil 2* (Rockport). Loomis lives in Arroyo Grande, California.

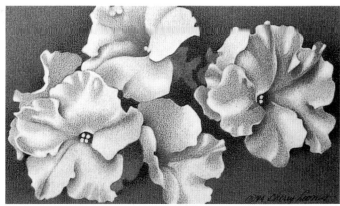

Judy McDonald is a native of Los Angeles, California, where she works as a professional artist and workshop instructor. Judy has had many one-woman shows, and her work is included in public and private collections worldwide. In 1991 her original colored pencil painting *Spirit of America* was presented to President Ronald Reagan at the opening ceremonies of the Ronald Reagan Presidential Library in Simi Valley, California. Lithograph copies of the original were given to all the living presidents who attended. She is a charter member of the Colored Pencil Society of America (CPSA) and her work has appeared in *The Best of Colored Pencil* (Rockport), *The Best of Colored Pencil IV* (Rockport) and *Creative Colored Pencil: The Step-by-Step Guide and Showcase* (Rockport). Visit her website at judymcdonaldart.com.

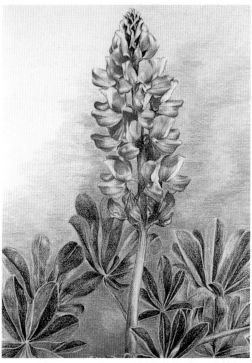

Terry Sciko is a native of Cleveland, Ohio. She completed her formal education at Cleveland State University with a bachelor of fine arts degree. Sciko embraces the challenges presented by flowers, both in her artwork and in her garden, enjoying their variety of types, colors and shapes. She has worked in ink, graphite and stone lithography and has studied graphic design and color theory. She, like most colored pencil artists, is self-taught. She prefers colored pencil because of its ability to capture the detail found in nature. Sciko is a Signature Member in the Colored Pencil Society of America (CPSA). Her works have appeared in the 1993, 1994 and 1995 CPSA International Exhibitions, and she was a finalist in *The Artist's Magazine*'s 1993 Annual Competition. Her work also appears in *The Best of Colored Pencil 2* and *3* (Rockport).

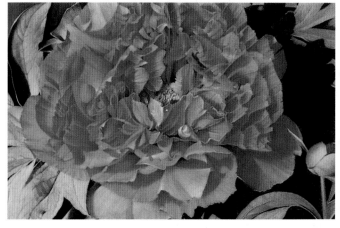

index

Creating Radiant Flowers in Colored Pencil. Original edition © 1997 by Gary Greene: Revised edition 2011 by Gary Greene. Manufactured in China. All rights reserved. No part of this book may be reproduced in any form or by any electronic or mechanical means including information storage and retrieval systems without permission in writing from the publisher, except by a reviewer who may quote brief passages in a review. Published by North Light Books, an imprint of F+W Media, Inc., 10151 Carver Road, Suite 200, Blue Ash, OH 45242. (800) 289-0963. Revised Edition.

Other fine North Light Books are available from your favorite bookstore, art supply store or online supplier. Visit our website at www.fwmedia.com

16 15 14 13 12 5 4 3 2 1

Distributed in Canada by Fraser Direct
100 Armstrong Avenue
Georgetown, ON, Canada L7G 5S4
Tel: (905) 877-4411

Distributed in the U.K. and Europe
by F&W Media International
LTD Brunel House, Forde Close, Newton Abbot, TQ12 4PU, UK
Tel: (+44) 1626 323200, Fax: (+44) 1626 323319
Email: enquiries@fwmedia.com

Distributed in Australia by Capricorn Link
P.O. Box 704, S. Windsor NSW, 2756 Australia
Tel: (02) 4577-3555

Edited by Holly Davis
Designed by Megan Richards
Production coordinated by Mark Griffin

ABOUT THE AUTHOR

In addition to being an accomplished fine artist, Gary Greene has been an art director, graphic designer, technical illustrator and professional photographer since 1967. He is the author of ten North Light Books, including *The Ultimate Guide to Colored Pencil, No Experience Required! Colored Pencil and Watercolor Pencil, Creating Textures in Colored Pencil,* and *Painting With Water Soluble Colored Pencils*. Gary has also produced five full-length colored pencil video workshops. He is a contributor to *The Artist's Magazine*, and his colored pencil paintings have appeared in *American Artist, International Artist, The Complete Colored Pencil, The Best of Colored Pencil* and *Creative Colored Pencil*. Gary is a fifteen-year Signature Member of the Colored Pencil Society of America and has taught workshops in art and photography internationally since 1985.

COPYRIGHTS

All contributor art used by permission.

© Susan L. Brooks: Calla Lily, page 44; Hyacinth, page 78; Water Lily, page 122; Calla
 Lilies, page 124.
© Edna Henry: Camellia, page 46; Geranium, pages 68–69; Petunia, pages 100-101;
 Summer Song, page 124.
© Kristy Ann Kutch: Daffodil, page 58; Lily, page 80; Tulip, page 119; Blazing Tulips,
 page 124.
© Sherry Loomis: Poinsettia, page 102; Primrose, page 104; Rose, page 108; Flora,
 page 125.
© Judy McDonald: Foxglove, page 65; Lupine, page 81; Sunflower, page 116; Blue
 Lupine, page 125.
© Terry Sciko: Aster, page 35; Carnation, page 47; Peony, page 98; Rhapsody in Pink,
 page 125.

Ideas. Instruction. Inspiration.

Receive FREE downloadable bonus materials when you sign up for our free newsletter at artistsnetwork.com/Newsletter_Thanks.

These and other fine North Light products are available at your favorite art & craft retailer, bookstore or online supplier. Visit our websites at artistsnetwork.com and artistsnetwork.tv.

VISIT ARTISTSNETWORK.COM AND GET JEN'S NORTH LIGHT PICKS!

Get free step-by-step demonstrations along with reviews of the latest books, videos and downloads from Jennifer Lepore, Senior Editor and Online Education Manager at North Light Books.

Follow us!

Follow North Light Books for the latest news, free wallpapers, free demos and chances to win FREE books!

GET INVOLVED

Learn from the experts. Join the conversation on